D1309938

ONCE UPON A TIME IN AMERICA

THE MOTTAHEDAN COLLECTION

ONCE UPON A TIME IN AMERICA

THE MOTTAHEDAN COLLECTION

With contributions by

CARROLL DUNHAM

TONY GODFREY

PETER HALLEY

JEFF KOONS

ALEXIS ROCKMAN

TIM ROLLINS

KARSTEN SCHUBERT
and
MOHAMMAD MOTTAHEDAN

CHRISTIE'S
BOOKS

TO MY FATHER, DR H. MOTTAHEDAN

First published in 1999 by Christie's Books Ltd.
8 King Street, St James's, London SW1Y 6QT

Volume copyright © 1999 Christie's Books Ltd.
Text copyright © 1999 Tony Godfrey, Mohammad Mottahedan + Karsten Schubert

All rights reserved.
No part of this publication may be reproduced, stored in a retrieval system or transmitted,
in any form or by means, electronic, mechanical or otherwise, without the prior permission
of the publisher.

British Library Cataloguing-in-Publication Data

A catalogue record for this book is available from the British Library

ISBN 0-903432-63-3

Photography by David Pountain + Douglas Chew-Ho
Additional photographs by Stephen White (pp. 100–101) + Christopher Burke (pp. 42–43)

This book was produced by Christie's Books Ltd.
Designed by Isambard Thomas + Joanna Pocock
Printed and bound in Italy by Amilcare Pizzi, S.p.A., Milan

Contents

ONCE UPON A TIME IN AMERICA

In the autumn of 1974, I arrived for the first time in New York City, where skyscrapers grew in a wild and modern jungle of light, sound and movement. I was immediately impressed by the fluid society, created by the activities of a cultural melting pot of people of a variety of race, colour, wealth and background. I did not speak English and I was not born in America, yet I felt a tremendous sense of freedom, no doubt as many before me who had emigrated across an ocean with hopes, desires and dreams.

The personality and culture I gained from the society into which I was born changed as a result of my interaction with Western society. The range of influences on society and the idealism of democracy particularly moved me.

Having finished my education in international finance, I started trading in financial markets. I observed the behaviour of the participants, noting their comfort in crowds, their various states of irrational exuberance or despair and, through the reflexive process, their tendency to trade the market away from value to extreme levels. When the leading traders set a trend, others would follow. The leaders would normally survive, whereas the stragglers would often find themselves stranded in extreme situations.

My experiences in the financial world taught me that although mankind can discipline itself with knowledge, experience and, thus, greater understanding, individuals are always influenced by the impulsive emotions of human nature.

In the spring of 1983 I went to the impressionist museum, in the Jardin des Tuileries, in Paris. When I saw the paintings of Van Gogh and Gauguin, I took a mental voyage to their world and was touched by the purity of the emotions expressed in

their work. This first exposure to art created in me a passionate addiction, and, unlike many other addictions, it became an uplifting and enriching experience.

In a quest to expand my knowledge, I visited the museums and cultural centres of Europe. Whenever I visited a new city, I was drawn less to the highlights of the social scene than to the culture of each country, expressed through its art. Each great cultural centre, from the Uffizi in Florence to the Louvre in Paris, had its own influence on my taste and development. My passion traversed the Renaissance to modernism. Through the work of the great sculptors and painters, I began to look at the world about me in a different way; even familiar places suddenly held new aspects and experiences.

When I saw Franz Klein's *Black Shadow on White* and Jackson Pollock's drip paintings in the Pompidou Centre in Paris, my curiosity about modern art was awakened. My new Mecca became the Tate Gallery in London, shortly followed by the Museum of Modern Art in New York. While researching this area, I started to visit art galleries and view the contemporary art sales at the main auction rooms and determined that I would understand what factors made modern art esteemed in a critical and historical sense and what had established the market value of the pieces. I enrolled in various art schools, read art history books and subscribed to art magazines to acquire a greater understanding of art and its history.

Viewing and studying art instilled in me a longing to participate in this world, but among the many careers associated with the art world such as artist, critic, curator or dealer, I was unable to find an appropriate path on which to focus my energies.

When I saw the Julian Schnabel retrospective at the Pompidou Centre in the winter of 1987, I noticed that under the title of almost every piece of work was 'Collection Saatchi, Londres'. Suddenly it occurred to me that as a collector I could satisfy many of the different aspects of the art world that interested me.

Interacting at many levels, art is created by a society with surplus wealth. Throughout history, artists have been nurtured and developed by patrons; the artists requiring the patrons' financial support to enable them to dedicate themselves to their work. The nature of patronage has developed significantly over the centuries and whereas commissions used to be a natural part of the artist's output, thankfully today a respect for freedom of expression has largely eradicated this procedure. Now the cutting-edge collectors give the artists their first break and support their careers until they generate the interest of museums and a broader public.

To me, art is not a question of skill or craftsmanship, but the creation and presentation of an image conceived in the mind and experience of the artist. It is the subtle variation in an original work of art that leads to extraordinary effects in the mind of the viewer. Great art transcends the cultural component and creates a mental phenomenon for anyone, regardless of cultural background, as long as he or she has a passion for art.

There have been many assessments of the contemporary art market from an investment point of view. I feel the risk of buying with a heavy bias towards investment far exceeds the rewards. Those who collect what they love with passion and courage will always find that tomorrow is another day. Whether the market for their pictures goes up or down, the works will still give them pleasure and they can be assured that, through the ages, art is re-evaluated in terms of price and historical importance.

The limiting factors in forming any collection are availability of the work and the financial ability to purchase it. Whereas I could not afford to buy one major old master or impressionist work, I managed to form a significant collection of art of my time. I purchased only what I loved and considered to be a major work of a great artist. I was the first owner of most of the works I purchased, yet I never felt that they truly belonged to me, but to the world of tomorrow. I believed that if others loved them as much as I did, they would live on long after me.

My individual history, knowledge, experience and the temporary hysteria to which we are all prone are reflected in the collection I formed 'Once Upon A time In America'.

Mohammad Mottahedan

SOME BECAME QUITE SANE AND SOME CAME OVER HERE

The English Reception of American Art in the Late 1980s

There are some strange paradoxes to the English reception of American art in the late 1980s. There is a tacit understanding that it was important and influential, but there were, with one notable exception, very few exhibitions in England devoted to it, the critics wrote little directly on it and little work, if any, was purchased by public collections. Therefore, the influence must be detected at an implicit level: the way terms such as 'neo-geo' or 'appropriation' and names such as Halley, Koons or Steinbach recur in the discourse. It would appear to be the case, although it is always difficult to demonstrate clearly, that the artists had a more profound understanding of this art and its implications than the critics. It helped, it has been argued, a younger generation of artists to rediscover Duchamp (and conceptual art in general) not as academic political correctitude, but in terms of pleasure and wit. It allowed a re-invigorated discussion on style, irony and the status of the object. In this discussion, or prior to it, Bruce Nauman and Andy Warhol re-emerged as key artists.[1]

The one obvious exception to the paucity of exhibitions for this art was the 1987 exhibition 'NY Art Now' from the Saatchi Collection at 98A Boundary Road.[2] What have been the consequences of so little of this art being seen subsequently? Was a knowledge, possibly false, of it ossified forever at this point? Certainly, for example, Steinbach has remained in the collective memory as the 'shelf man': his word pieces remain unknown in England, his first solo show there was not until 1998 in Southampton.[3] Carroll Dunham's work likewise was unseen in London between 1987 and 1998. Meyer Vaisman's work has scarcely been seen since 1987 and Christopher Wool, despite his reputation and his exhibiting regularly throughout

America and continental Europe, remains effectively unknown.[4] (In fact of all the artists associated with appropriation, Robert Gober, who emphasises making, has been shown the most in England, along with Ross Bleckner, whose painting was clearly emotive, if not downright sentimental.) Despite the fact that English artists themselves generally travelled and saw the later work, either in New York galleries or in exhibitions on the continent, the subsequent development of the New Yorkers and the complexity of their work as a whole was not fully understood.

If 'NY Art Now' acts as one benchmark, the exhibition 'Some Went Mad, Some Ran Away', curated by Damien Hirst at the Serpentine Gallery in 1994, acts as another. In it, English artists were intermingled with other European and American artists, including Alexis Rockman and Ashley Bickerton. In 'NY Art Now' American art was presented as — and was universally seen as being — radically different to the English, whereas in 'Some Went Mad, Some Ran Away' there was no sense of such radical difference; instead Americans and the English were friends and equals, with shared interests and approaches.

Arguably, the New York appropriation art[5] of the mid-1980s was the last movement with any sense of critical coherence. The British art of the late 1980s, which I would argue was crucially affected by New York appropriation, lacked any such ostensible intellectual programme – as is seen by the constant recourse subsequently to such anodyne terms as 'new' or 'young' to describe or label it.

It is important to be aware of the situation in London around 1986–87. The major exhibition of 1986 (at the Royal Academy)

had been a vast survey of German art of the twentieth century; the major exhibitions of 1987 were a retrospective of Tony Cragg and 'Falls the Shadow', a controversial survey of contemporary European art with a bias towards the poetic and symbolist. In short, the prevailing interests were national identity, the new British sculpture and expressionism. At that point, Baselitz, Kiefer, Cragg and Deacon were probably the most discussed artists. German art dominated the pages of *Artscribe*, whilst the other major art magazine, *Art Monthly*, seemed pre-occupied with the morality of public sculpture and the arguments presented by a now-forgotten critic, Peter Fuller, for a return to English romanticism.

Although it enabled the death warrant to be handed out to the fifth generation abstraction expressionists and the third generation post-painterly abstractionists (mawkish imitators of de Kooning and Morris Louis, who dominated the art schools and establishment), neo-expressionism from Germany and Italy (Baselitz, Kiefer, Clemente *et al.*) had little lasting influence on English art. Equivalent painting in England remained very much 'art' – concerned with nature and tradition rather than the everyday and the urban. In contrast, in Germany, it was intimately linked to pop culture – witness the nightclub paintings of Fetting and Middendorf and the attempt by the magazine *Wolkenkratzer* to discuss rock music and painting conjointly. In the same way, *Figuration Libre*, the French version of neo-expressionism, was closer to popular culture, being very much a rapprochement with *bandes dessinées* (cartoon books). Yet, despite remaining confined to the gallery, neo-expressionism in England helped re-open subject-matter and impropriety to artists: fantasy, confession, parody and eroticism. In this, it combined paradoxically with the revived interest in conceptualism.

The formalism that had dominated English sculpture in the 1970s had been displaced by the sculptors associated with the Lisson gallery. Although in retrospect they form a more diverse group than was recognised at the time, they, unlike artists such as Koons or Steinbach, put a great emphasis on forming and on hand-work, even when they worked with urban detritus. Moreover, their work had a relatively traditional, organic relationship to metaphor.[6] So a Deacon sculpture might *refer* to the ear, a Kapoor to wings or the void, and a Cragg to an axe-head or tower. Images or metaphors existed naturally as a resource of tradition. However, the objects and images had always been transmuted clearly into *art*. It should also be remembered that until the mid-1980s it was probably Eva Hesse (or the myth of Eva Hesse), with her organic shapes

and supposed ability to infuse sculpture with autobiographical meaning, who was the American sculptor most discussed in art schools.

Before the actual arrival of this 'new' New York art, it was extensively discussed in *Artscribe*, where for a period it supplanted German neo-expressionism as the thing to talk about, if not actually see. It is difficult to think of another occasion when the critical discourse has arrived in London lock stock and barrel before the actual material.[7] Crucially these 'bought-in' articles and reviews were by Americans in New York rather than English writers going there. This meant that a full discussion of the work by English writers was effectively forestalled. It also created a certain sense that this American writing could be too easily dismissed as intellectually pretentious advertising or packaging. Since Peter Halley's 1984 essay 'Crisis in Geometry', people had been intrigued by this recourse to Foucault and Baudrillard in art criticism.

Quite apart from the articles, interviews and reviews in *Artforum*, *Art in America* and *Flash Art*, it was possible to find several good and well-illustrated catalogues of this work in the bookshops of London, notably *Art and its Double* from Barcelona, with an introduction by Dan Cameron, and *Endgame* from Boston with essays by Yve Alain Bois, Thomas Crow, Hal Foster, David Joselit, Bob Riley and Elisabeth Sussman.[8] Importantly, this is the moment at which the English art world began to read a new generation of American critics who combined a liveliness and savviness with theory. However, as Peter Halley said in 1995, 'despite all the talk about new developments in telecommunications, critical debate is still a very local phenomenon'.[9] What is published in the local, indigenous press is always more important, and the discussion in the bar or restaurant more important still.

Indicatively, the first discussion of this work in *Artscribe* was in an interview with the art consultant turned critic Jeffrey Deitch, an enthusiast for the work, who emphasised its intellectual coherence and claimed that the work had been unusually, but symptomatically, recognised first by a group of collectors rather than by critics or museums. It was also telling that accompanying this interview was an attack on the new art by Donald Kuspit, the self-appointed dean of neo-expressionism and Beuys studies. He described it as narcissistic and necrophiliac and saw their 'smooth, shiny, decorative surfaces' as the symptom of sick art. This was in keeping with his polarisation elsewhere of Beuys (deep, healthy

and spiritual) and Warhol (superficial, unhealthy and cynical). Such polarities were to be commonly expressed at the time. They seem *naif* now.

Well in advance of their London arrival, *Artscribe* even went to the extent of commissioning John Miller and Ronald Jones, both artists themselves, to write a series of important reviews of shows by the major appropriationist artists in New York: Rollins, McCollum, Koons, Nagy, Steinbach (they both reviewed this to make it clear that it was important), Lemieux, Vaisman, Bickerton, Prince and Halley. Lynne Cooke even, in effect, reviewed the Boundary Road exhibition before it had opened.[10] In this intriguing article, she tries to locate this work both in terms of the sculptural theories she had been expounding and pop art (the title echoes that of Richard Hamilton's famous collage). At the time, it felt as if one had gone to the theatre and the plot was being read out before the play actually began. Also, crucially, even before the artists had arrived, it seemed that their personalities rather than their artworks were being sold: Robert Pincus-Witten wrote in *Artscribe*[11] not of the exhibition but of the artists at a symposium in terms of what they sounded like, how they posed and how they played the art world. Even Lynne Cooke was moved to describe Koons in the august pages of the *Burlington Magazine* as an operator, 'a former stockbroker, with a brilliant analytical mind, single-minded ambition and relentless drive, Koons is a strategist of exceptional skill and acuity'.[12] Later on, of course, any critical discussion of the works was to be totally submerged by gossip about Jeff Koons' sexual exploits and family life.

The first appearance of such art in London 'in the flesh' was Haim Steinbach's *Untitled (Cabbage, Pumpkin, Cabbage)*, of which Mary Rose Beaumont, representing accurately the bemusement of middle-brow taste, wrote: 'the vulgarity of whose work is hard to ignore. The sculpture is a piece of modish plywood furniture, very like Donald Judd's recent multiple shelf piece, attached to the wall. At either end is a soup tureen in the shape of a cabbage, available in two sizes, and the whole edifice is crowned with an orange fur felt pumpkin sporting a black burglar mask and sprouting green felt hands and a lock of hair in the same material. To complete the carnival atmosphere the creature's cheeks are touched with little circles of rouge. Fun for the toyshop, but is it art?'[13]

Again she spoke for many reviewers when, in describing the full invasion of New York art at Boundary Road, she spoke of 'the shock of actually seeing the things';[14] nevertheless there was a feeling that she and others still responded as much to what they had read of the work as what they saw. She wrote with disarming naiveté that Steinbach's 'formica plinths refer back to Judd and Armleder. So you will see that appropriation is the name of the game.'[15] Many reviews in the British press were dismissive, smug or sniffy – albeit entertained. Typical was Waldemar Januszczak: 'Neo-geo is a smart, cool, urban art that in its present London venue, serves as an extended tirade against the British body-shop aesthetic ... a paean to synthetic substances.'[16]

Before the arrival of 'NY Art Now', *Art Monthly* had managed to say nothing on any of these artists and, indeed, after having reviewed the show, they felt obliged to say nothing more on the subject for three years. The review by Michael Archer was a full-blown assault;[17] he claimed that these artists lacked any manifesto for social change or enlightenment and that they were imitative, full of 'melancholic torpor' and of no consequence except as an epiphenomenon of art-world fashion. 'The work in 'NY Art Now' is sub-Duchampian and it is parochial; its problems are more its own than it likes to think. It is sub-Duchampian because it is neither sufficiently positive to warrant the prefix 'neo', nor adequately penetrative, in intellectual terms, to command a qualifying 'post'. It is parochial because it is symptomatic of its surroundings, not resistant to them. This is work which wallows shamelessly in its own irrelevance.'[18]

Yet one factor above all else suggested it was in fact far from irrelevant: the number of young artists and art students who went. As Beaumont noted, 'on the day I was there the gallery was packed, mostly youngsters, hugely enjoying themselves, a rare enough happening'.[19]

The exhibition signalled a generation divide in English art. Whereas an older generation dismissed it or were fascinated solely by the intellectual argument (whether it subverted market values or reinforced them and in what way it related to Baudrillard and Foucault); the response of a younger generation was to the visuality of the objects. They were interested in the way things were displayed, the use of geometry, the everydayness, the beauty and the way they mutated nature.[20] They looked more than they read. Their interest seems historically correct: the objects have lasted. They retain a fascination far above some ploy about the vacuity of the market. The young artists understood this fascination, the ambivalence of the work and how it was simultaneously beautiful and ironic. Halley, both in his essays and paintings, showed that directness and irony can co-exist. Koons showed that the banal and beautiful were far from incompatible.

Steinbach demonstrated that kitsch and formal decorum could be matched.

Three years later, an interesting article by Robin Marriner appeared in *Art Monthly*, providing evidence that a general re-think was underway. Marriner argued both against the way American critics often enforced a Baudrillardian reading on this work (often based itself on a poor reading of Baudrillard) and against the way Lynne Cooke, as official spokesperson for Lisson sculpture, discussed it as being only acceptable in so far as it related to minimalism (so Koons is better than Steinbach to her because he is more minimal). What was fascinating about Koons and Steinbach, Marriner argued contrarily, was the complexity of their work – it's success could never be adjudged formally alone. Although, ostensibly, it offered the same pleasures as a shop display, it was in fact deeper and more sophisticated. It was more ambivalent than either shop design or minimalism. It raised issues of beauty and rightness. It was at once dumb and highly articulate.

By then, a new generation of artists, who had been students at the time of appropriation's advent, was beginning to emerge. The bluntness with which Hirst showed boxes of maggots and butterflies, with which Michael Landy presented one hundred market stalls and with which Matt Collishaw presented the image projected of a woman in bondage made Koons or Steinbach seem relatively 'arty'.[21] 'Display' was the term Caroline Russell used for a whole series of work beginning in 1987 that mimicked shop window display.[22] Their reading of the New-York art was affected by a previous encounter with minimalism,[23] and, as with that experience, it was as much the installation as the work itself that moved them – with lots of space, they were like glistening prototypes for Christmas. If the motto for the early 1980s was to reveal oneself, now it became to display objects and, perhaps, oneself. (As women are objects in our society, it is inevitably the women artists, Sherman above all others, who display themselves.)

One thing rarely noted by critics was how work by Koons and Steinbach met that of Charlesworth and Lawler in being no just about shopping (consumption) but also interiors (living). This fitted with a widespread interest in interior design and collections.[24] The sometimes amiable, sometimes acerbic, burlesque of objects as sold and used and, in being used, becoming redolent of lived experiences, has been central to work by English artists such as Rachel Evans, Abigail Lane, Sarah Staton and Tracey Emin. Also the way objects can represent communal life – a concern of Steinbach's – has been very much a goal for Michael Landy.[25] New York art

helped this generation re-invent the everyday as an elegant machine. Whereas earlier it had been a category noted more for its worthiness and dowdiness, now it could be stylish or phantasmagorical (in the case of Steinbach or Sherman both).

Another stage in the English reception of this art was the inclusion of works by Koons, Steinbach, Lawler, Halley, Vaisman *et al.* in 'Objects for the Ideal Home: The Legacy of Pop Art' at the Serpentine Gallery in 1991.[26] Coupled with a major pop-art retrospective, it emphasised how crucial this way of re-thinking the object was and how it connected with our attitude to possessions in interior spaces. Although the context and discussion was still geared to far too great an extent to kitsch and consumerism, it was clear that these works were closer in their ambivalence to the hermetic work of Richard Artschwager than mainstream pop.

From 1987 onwards, many reviewers had had to admit reluctantly how beautiful they found Koons' *Bunny,* but the extent to which a sense of beauty was being rediscovered in the dangerous area of kitsch was not generally recognised by the critics. The piquancy of the colour combinations in Halley was not colour blindness, but a desire to push the eye. This was akin to what Fiona Rae in a far less theorised way was already doing. It was potentially lyrical, and, in its unexpectedness, potently lyrical, as was Steinbach's or Vaisman's work. The presentation of the beautiful and the evocation of the lyrical were central to the displays of Collishaw and Anya Gallaccio.[27]

The photographic works of Jane and Louise Wilson and Sam Taylor Wood likewise ran parallel not only to the display or staging of the self in Cindy Sherman and Laurie Simmons, but to their fascination with intermingled beauty and repulsion. Koons' use of female beauty, whether it be in such an image as his *Woman in Bath Tub* or the collaborative works with La Cicciolina, had an immeasurable effect on English art as elsewhere.

Mutation was a little-noticed trait of this New York art. It became more apparent as the work of an artist such as Carroll Dunham developed. Nevertheless, stylish though his work was, from the beginning it evoked the visceral without relying on blood-and-guts expressionism. Likewise, its centrality to Vaisman's work only became clear as his work developed. Paralleling the advent of cloning in science came the helter-skelter mutating of Alexis Rockman and the Chapman brothers. A mutual interest in science fiction and the natural sciences surfaces in Rockman's *Biosphere* paintings, Glenn Brown's paintings after Chris Foss and Graham Gussin's drawings of

imagined landscapes. It is no coincidence that the key 1993 exhibition of British art, 'Wonderful Life', should be named after Stephen Jay Gould's famous book on the Burgess shale and the profligacy of early forms of life (an argument in another discipline against modernist notions of progress), and that Rockman should have Gould write his 1995 catalogue essay.[28]

Two famous paintings, entitled *The Tree*, by Baselitz from 1965, show an injured tree, bandaged and bleeding. The tree here, by the most likely reading, is symbolic of the state of German culture. When Alexis Rockman painted his *Phylum* in 1989, he reversed this: he made real the metaphor of a concept – a tree of species – rather than a real tree as metaphor. Indeed in its complexity and pre-considerness it is more simile or allegory than metaphor. Comic rather than tragic, it looks to science and ecology for a sense of being in time and place rather than to nationhood and personal authenticity. As Gould notes, Rockman adopts Haeckel's famous 1866 diagram of the 'tree of life' by making not just the species coming from it but the tree itself change form as it goes up – a simile of a simile.

It has been remarked how metaphors in art of the early 1980s whether it be Deacon or Baselitz, operate in a relatively traditional way. In comparison, Halley's cell metaphor is crassly flagrant: we are unsure whether it is homage, parody or merely structurally contingent. Likewise, in Steinbach, the normal shift from object to metaphor is breached and the metaphor of the shelf itself is a problematic one. Again, with Tim Rollins, the use of metaphor initially seems obvious, but then it transpires, as we try to relate it to the text to be expressed in an uncertain context. We could find equivalences in Marcus Harvey's reworking of pornographic imagery, or, notoriously, the face of Myra Hindley.

Finally, is 'influence' the right word here? Should we not refer instead to a confluence of interests? If it is influence, it is not to do with a stylistic trait, as in traditional *Kunstgeschichte*, but with an attitude and way of using things in the world. The institutional reception of this art in England has scarcely begun, but its reception by artists has been a fruitful one, both for them and for us – their work helping us to see the work from New York anew.

Tony Godfrey

Notes

1 Symptomatically, *Artscribe*, in January 1988 positioned a reproduction of Duchamp's *Bicycle Wheel* right next to a Steinbach shelf piece.

2 This included, of artists in the Mottahedan Collection, Dunham, Halley, Koons, Rollins, Steinbach and Vaisman.

3 At the John Hansard Gallery, Southampton. It was a deliberate attempt to ameliorate this situation. However the exhibition, whittled down from a much larger exhibition in Vienna, consisted only of shelf pieces. The Director, Stephen Foster, decided that as these works were so little known, it was best to concentrate on them.

4 To my knowledge, he has only shown twice in London: in group exhibitions at Karsten Schubert's gallery in 1990 and 1991.

5 The label is unsatisfactory, but, along with the term 'neo-geo', it seems to be one we are stuck with in the same way as 'impressionism' and 'fauvism'.

6 There are exceptions to this, notably Richard Wentworth and Edward Allington, who were more interested in the use of objects and the status of kitsch respectively. Both, indicatively, were influential teachers.

7 It is worth detailing the following:
No. 57 April/May 1986
Jeffrey Deitch interviewed by Matthew Collings
'Young necrophiliacs, old narcissists', Donald Kuspit

No. 58 June/July 1986
'Ready-mades on the couch,' Michele Cone
Review, Ashley Bickerton, Rex Reason
Review, John Miller, Donald Kuspit

No. 59 September/October 1986
Review, Ti Shan Hsu, Donald Kuspit

No. 60 November/December 1986
Review, Lemieux/Bleckner/Rollins, Ronald Jones

No. 61 January/February 1987
'Regressive reproduction and throwaway conscience', Donald Kuspit
'Allan McCollum's surrogates', John Miller
Review, Jeff Koons, Ronald Jones

No. 62 March/April 1987
'In the beginning there was formica', John Miller

No. 63 May 1987
Tim Rollins & K.O.S., Rosetta Brooks
Ti Shan Hsu, Claudia Hart
Review, Allan McCollum, John Miller

No. 64 Summer 1987
'Entries: electrostatic cling', Robert Pincus-Witten
Review, Peter Nagy, Ronald Jones

No. 65 September/October 1987
Tricia Collins and Richard Millazo, interviewed by Matthew Collings pt 1
'Entries: What are you doing after the orgy?', Robert Pincus-Witten
'Object Lessons: Just what is it about today's sculpture that makes it so different, so appealing?', Lynne Cooke
Review, Haim Steinbach, Ronald Jones
Review, Haim Steinbach, John Miller
Review, Annette Lemieux, Ronald Jones
Review, Jonathan Lasker, Jutta Koether

No. 66 November/December 1987
Peter Halley and Meyer Vaisman, interviewed by Claudia Hart
Tricia Collins and Richard Millazo, interviewed by Matthew Collings pt 2

No. 67 January/February 1988
'Slow time: Sherrie Levine's new work', Ronald Jones
'The consumption of everyday life', John Miller
Review, Louise Lawler, Claudia Hart
Ronald Jones, Pat McCoy

No 68 March/April 1988
Ros Bleckner, interviewed by Stuart Morgan
Review, Meyer Vaisman, Ronald Jones

No. 69 May 1988
'Anamnesis: the work of John Kessler', Lynne Cooke
Review, Gary Stephan, Claudia Hart

No. 71 September/October 1988
Ashley Bickerton, Ronald Jones
Review, Richard Prince, John Miller

No. 72 November/December 1988
Review, Gober/Wool, Steven Evens
Review, Bill Beckley, David Shapiro

No. 74 March/April 1989
Jeff Koons, Stuart Morgan *et al.*
Project by Christopher Wool
Peter Halley, John Miller

No. 75 May 1989
Monkey business (Meyer Vaisman), Ronald Jones
Review, Alexis Rockman, Roger Denson

No. 77 September/October 1989
Annette Lemieux, Roger Denson

No. 78 November/December 1989
Forest of Signs, Jeremy Gilbert-Rolfe

Although not an inclusive list, it clearly shows how interest built to a crescendo in 1987, and how the coverage was almost exclusively by American writers. Every single exhibition reviewed was in New York, not one in England.

8 Both catalogues accompanied 1987 exhibitions: 'Endgame' at the ICA Boston, and 'Art and its Double' at the Centre Cultural de Caixa de Peniones.

9 'Paris Symposium # 1995' reprinted in the exhibition catalogue, Peter Halley, Syracuse, 1997.

10 Lynne Cooke, 'Object Lessons: Just what is it about today's sculpture that makes it so different, so appealing?', *Artscribe*, September 1987.

11 See his articles in *Artscribe*, Summer 1987 and September/October 1987.

12 Lynne Cooke, *Burlington Magazine*, March 1989.

13 *Arts Review*, August 1987.

14 *Arts Review*, 9 October 1987.

15 As note 14, above.

16 Waldemar Januszczak, *Connoisseur*, December 1987.

17 Amusingly, when Archer became editor of *Artscribe* in late 1989, he proceeded to commission articles on *inter alia* Richard Prince, Louise Lawler and Jonathan Lasker.

18 *Art Monthly*, November 1987.

19 *Arts Review*, 9 October 1987.

20 Geometry was perhaps the aspect least addressed by English artists, although Liam Gillick's conversation islands have a curious relationship to this.

21 Hirst in 1991, Landy and Collishaw in 1990.

22 Perhaps because it could not advance to the metaphoric, this series petered out.

23 In the opening two shows of the Saatchi Collection 1985–86.

24 Witness both the success of *The World of Interiors* as a magazine and the interest in Elaine Scarry's book *The Body in Pain*, which discussed cogently how the room is an extension of the body.

25 It was not until a conference about Steinbach at the Tate in 1998 that the work was actually discussed in terms of social archaeology: how people place objects in their home and how arrangements of objects show personality and desire.

26 Included were Steinbach's *Untitled (Cabbage, Pumpkin, Cabbage # 1)*, Vaisman's *Still Life with Portrait* and Koons' *Winter Bears*.

27 Curiously, Steinbach's collaborative show 'Osmosis' with Ettore Spalletti at the Guggenheim, New York, in 1993 was seen by a surprising number of English people – this collaboration with an artist dedicated to ideal forms and the resulting emphasis on symmetry and beauty went against the received assumption of what this art was about.

28 Stephen Jay Gould, 'Boundaries and Categories', in *Alexis Rockman: Second Nature*, University Galleries of Illinois State University, 1995.

NOW YOU DON'T SEE IT, NOW YOU DO
American Art of the 1980s in Context

'How would you like it if we tried to compose
a history?'
'I would like nothing better, but which?'
'Indeed, which?'
GUSTAVE FLAUBERT, *Bouvard and Pecuchet*

'I'm making some of the
greatest art being made now.
It'll take the art world ten years
to get around to it. In this
century there was Picasso and
Duchamp. Now I'm taking us
out of the twentieth century.'
JEFF KOONS, *The Jeff Koons Handbook*

When the title of this book, *Once Upon a Time in America,*
was first suggested by Mr Mottahedan, it struck me as a perfect
way of illustrating the strange and ambiguous attitude that
prevails today with regard to art of the 1980s in general, and
to American art of that period in particular. It is a title that is
simultaneously both matter-of-fact (in placing something firmly
in the past) and deeply elegiac, even sentimental in suggestion.
The title points to something that is finished and over and done
with, yet at the same time much missed. It describes an
absence that is very keenly felt.

It is a commonplace observation that each generation
denies that which went before. By the same token, each new
decade seems to be the antithesis of the one that predates it.
Strangely, this quite straightforward dialectic does not even

begin to account for the fate which has befallen the art of the
1980s. From being widely collected, discussed, exhibited and
admired, it has, for most of the 1990s, descended into a critical
limbo, where it is hardly ever referred to, other than in passing
or in a disparaging way. As neither the art nor the artists have
changed, we must be facing a more fundamental phenomenon
– one that reaches well beyond the hold-all explanations of
historical cycles or the caprices of changing taste and fashion.

It seems that the fall from grace of 1980s art might point to
a seismic shift in sensibilities. Yet the clandestine longing for
the decade indicates that we recognise something in it which
is still pertinent to the present situation, but to which we would
rather not admit.

How our perception of American art of the 1980s fits into the
wider picture of cultural change is the theme of the following
reflections. For me, American art of the period is epitomised
by the works of Ross Bleckner, Carroll Dunham, Robert Gober,
Peter Halley, Jenny Holzer, Jeff Koons, Barbara Kruger, Sherrie
Levine, Alexis Rockman, Tim Rollins & K.O.S., David Salle,
Cindy Sherman, Haim Steinbach, Philip Taaffe, Meyer Vaisman
and Christopher Wool, to name but a few.

Virginia Woolf observed in *A Room of One's Own* that works
of art 'are not the product of single and solitary births; they are
the product of many years of thinking in common, of thinking
by the body of the people, so that the experience of the mass
is behind the single voice'. Woolf's statement points to the fact
that works of art are not created in a creative vacuum, but that
they are part of a dialogue that encompasses all aspects of
contemporary civilisation. The best art is of its time and yet
transcends it. Perhaps it should be added that what she says

is also true about the reception of works of art once they have left the confines of the studio. The fate of 1980s art, its instant apotheosis, fast fall from grace and gradual resurrection, comprises a fascinating chapter of cultural history and an affirmation of Woolf's observation.

The 1980s was the decade of post modernism. There had been a suggestion before that a massive cultural sea-change was under way, but only during the 1980s did it reach critical mass. By the end of the decade, post modernism was well established – it had seeped into every aspect of cultural life.

True to definition, it was not a decade that was creative in a classic and modernist sense; rather it allowed the mining of history in a most liberal and unprecedented fashion. The discovery of the past as a repository of images to be exploited for present-day uses ran counter to all modernist principles, and, indeed, the unease many commentators felt initially may have been the result of judging the new, post-modernist circumstances according to old, modernist standards. In this context, it is revealing to note how muted the institutional support for the new art was. Unprepared for the change from the (modernist) élite culture to the (post-modern) mass culture, those in charge of museums, to paraphrase Walter Benjamin, sought nothing beyond acquiring credentials for the post-modern artist from the judgement seat that he had already overturned. They were often not even as generous as that but turned their back on the new art completely. In this respect, the exclusion of American art of the 1980s from the 1992 Documenta 9 in Kassel is one of the most censorial declarations of curatorial disapproval on record.

The recycling of images and stances, appropriation and simulacrum, ironic pastiche and double entendre, allegory and metaphor, not only were these strategies deployed by artists, but their working can be detected in every area of 1980s culture. Politics, architecture and fashion all used similar, if not identical, methods. It seemed that not only did all these areas function simultaneously according to a new set of rules, but that it was possible to apply the same interpretative apparatus to the different arenas. The result was a decade of rare cohesion (and it may be this cohesion that, for so long, made it difficult to look at the art of the period).

In America, the election of Ronald Reagan to the presidency in 1981 heralded the institution of socio-Darwinist policies under the guise of old-fashioned conservatism. In Britain, in the name of a return to Conservative principles, Margaret Thatcher (first elected Prime Minister in 1979) had set off a similar radical shake-up. Like Reagan, the radicalism of her strategies was couched in the reassuring language of home-county conservatism. In reality, during her first term in office, Thatcher set in motion a far-reaching overhaul of Britain's economic base and social fabric. Her mantra was an appeal to self-interest and self-reliance, paired with the denial that there was any common interest other than allowing individuals to pursue their own goals: 'There is no society but only individuals.'

Deploying a language of rhetorical bombast, and invoking historical models ranging from Boadicea to Queen Victoria and Churchill, Thatcher could be described as one of the first truly post-modern politicians. In exploring the entire inventory of historical images, no cliché was too obvious for her and no suggested parallel too far-fetched, provided that they had the desired effect on her audience.

Architecture likewise succumbed to the appeal of post modernity. The modernist dictum of 'less is more' made room for the Wildean 'nothing exceeds like excess'. Pastiche, quotation and ironic reference became the staples of architects all over the world. The relatively instant success of post-modern architecture precipitated its equally swift demise. By the end of the decade, every hack-architect was churning out 'quotation' buildings of increasing vacuity and awfulness. What had started as a rhetorical challenge to modernism had quickly declined into commonplace vernacular. The only true casualty of the 1980s, it seems, was post-modern architecture. Its quick decline has heralded the return to more modernist principles and models.

In film, ironic quotation, self-parody and pastiche took root with equal strength, not just in art-house but in also in mainstream releases. This allowed, for the first time, the combination of genres that in the past had been considered incompatible. The result was a long-overdue renaissance of commercial film-making as well as the occasional unprecedented conflation of art house and mainstream.

In fashion, too, pastiche and quotation ruled. The repertoire of fashion history became a gigantic source-book for the present. One retro-look followed another, and many designers were happy to parody their own past. This reliance on the past went hand in hand with an insistence on luxury and ostentation. Not since the days of the ancienne regime had fashion been so set to impress. No longer content with designing clothes, designers set out to sell 'lifestyles'. Every aspect of daily life, however mundane, became the subject of designer attention.

If one tries to identify a common denominator for these simultaneous shifts towards a post-modern aesthetic, the words 'façade', 'skin' and 'surface' might be used. Appearances were

everything. Even the financial sector succumbed to the lure of this, and 'leverage' and 'arbitrage' became the buzzwords of the age.

The reassuring and principled, perhaps even moral, certainties of modernism were set aside to allow for the much darker and dangerous glamour of relativity. Modernism had a penchant for hierarchy, chronology, order and normative classification, whereas post modernism based itself on anti-hierarchy, anti-chronology, anti-order and anti-classification. Modernism was everything post modernism was not.

The neo-conservative appeal to self-interest, combined with high tax incentives and unprecedented financial deregulation, had set off a world-wide economic boom. When this proved unsustainable towards the end of the decade, it was inevitable that doubts, disillusionment and disappointment would set in. Both Reagan's and Thatcher's hard-line stance left no room for reversals or the ups and downs of economic cycles. Neither Reagan nor Thatcher was in any way prepared politically for the unavoidable economic reversals. Towards the end of the decade, a widening gulf opened up in Britain between Thatcher's declarations and the reality faced by the country. This gap gave the impression that she had lost touch, finally precipitating her fall from power in November 1990. This was preceded by the fall of the Soviet Union the previous year. By the beginning of the new decade, many of the defining symbols of the 1980s had been discredited, had disappeared or had changed beyond recognition.

Ironically, the recession of 1990–92 hit hardest those who had been the most ardent election supporters of Reagan and Thatcher: the middle classes. Their enthusiasm gradually turned into disillusionment and angry frustration. A deep unease with the values and priorities of the previous decades set in. The damage to social cohesion, and the realisation that it was the poorest who had benefited least, was beginning to make people feel extremely uncomfortable. A 1980s backlash was inevitable. By the early 1990s, to describe anything as 'very 80s' had become convenient shorthand for the most withering critique. It was precisely the cultural cohesion already noted above that lead to the wholesale dismissal of every aspect of the decade, irrespective of individual merit.

The Mottahedan Collection's shift towards young British artists at the end of the 1980s was not accidental. The cultural disorientation that had set in elsewhere in the world did not affect Britain to the same degree. In fact, quite the reverse occurred. The loss of the Empire, the shift from central position to the sidelines, the transition from one mode of industrial production to another and large-scale economic decline were all experiences Britain had already gone through in the preceding 150 years, and in reply to which it had developed a multitude of specific cultural and political responses. Now Britain's faded glamour and controlled decline was not out of synch, but could be read as a paradigm for a worldwide state of affairs. The British experience was no longer particular to this country alone, but could serve as a model for most Western nations. Thus, with hindsight, Britain's inability to come to terms fully with modernism for most of the twentieth century could be interpreted as a particular formulation of post modernism avant la lettre.

Now, as the 1990s are about to pass into history, it is possible to take a less partisan look at the 1980s. We can see that the present decade is not quite so antithetical to the 1980s as we thought even five years ago. It is becoming clear that the two decades are actually marked not so much by a cataclysmic break but by continuity.

Art, politics, fashion, film, architecture and popular culture remain deeply indebted to the post-modern models and strategies of the 1980s. In politics, total image control, as first practised by Thatcher and Reagan, has now become so commonplace that it is hardly commented on at all. Britain has witnessed the re-invention of the Labour Party by appropriating the entire stock of successful Conservative principles, minus Thatcher's shrillness and self-righteousness. Tony Blair's pragmatism owes much more to her than to Old Labour. American politics show an equal, if covet, indebtedness to Reagan. As for Britain's special relationship with America, Thatcher invoked it incessantly and her American counterparts indulged her in this, even if it was in the way a weary parent indulges a tiresome child. Today it has become a matter-of-fact working relationship, the terms of which are dictated by the day-to-day flow of world politics.

Fashion has moved from big and ostentatious to understated and minimal, yet the closets of history are still plundered with each changing season. If anything, consumers today are even more image conscious than in the previous decade, and it has been argued that post modernism is nothing but the reverse of the late-capitalist coin. In the light of the gigantic fortunes that are being created today by the new information technologies, the critique of the wealth of the 1980s sounds rather churlish. Donald Trump has given way to Bill Gates as the favourite capitalist pin-up. The crassness of conspicuous consumption has been replaced by 'stealth wealth'. Technologically, the revolution set in motion at the beginning of the 1980s with

the introduction of the personal computer has found its apotheosis with the Internet, the most perfect technological expression of the post-modern mind set to date.

One of Reagan's most treasured images, that of America's role as a world power, has finally become a reality. No longer locked in to a stand-off with the Soviet Union, America is now the only global power on the planet. Its economic and military might are unrivalled, even though the role of global police turned out to be less glamorous than the gung-ho rhetoric that the Cold War had implied.

If post modernism had gradually emerged from the 1960s onwards, it was American art of the 1980s which was its most comprehensive formulation. The American artists of the decade were the first to acknowledge this cultural shift, not just in passing but by making it the central theme of their discourse. In the process, they gave us the most cohesive formulation of post-modern principles in the visual arts. As the decade recedes into history, it is becoming increasingly clear that post modernism was not decade-specific, something that began and ended with the 1980s, but that it has in fact firmly taken root as the basis of all cultural dialogue. The post modernism of Western societies is still proceeding at a pace. In this light, it may come to pass that we will look at American art of the 1980s in the same way that we have come to view the icons of early modernism from the beginning of the century, namely as the key to an understanding of what follows and as the benchmark against which all else has to be measured. American art of the 1980s may hold the key to an understanding of our own cultural circumstances at the beginning of a new century.

Karsten Schubert

HALLEY, Peter
River's Edge, 1990

PETER HALLEY

MM: In your painting *River's Edge* (1990), where you use grey and white on one side of the diptych and colours on the other, does the thought behind this relate to Aristotlian binary logic; 'A or not-A, black or white', the Buddhist belief systems according to which you find the world filled with contradiction (hence the grey theme) or the science of fuzzy logic which means multivalence instead of bivalence? What are the psychological thoughts in their organisation?

PH: *River's Edge* was the second of two diptychs that I painted in 1990. Both had a full-colour panel on the left and a grisaille panel on the right. The first painting was *Double Elvis*, whose left-hand panel was yellow, red, pink and orange. *Double Elvis* had a kind of mid-1960s euphoria that I associated with pop art and the Day-Glo optimism of that era. *River's Edge* was intended as a more sombre sequel, as is suggested by its title, which referred to the bleak and uneasy movie that appeared in that year. In *River's Edge*, the colours in the top left-hand panel remain the same, but in the base, the Day-Glo pink and orange are replaced by more sombre broken earth tones.

My primary reference in making these paintings was art-historical. I had long been interested in Jasper Johns' playful grisaille- and primary-hued versions of the same paintings. I was also specifically thinking of Frank Stella's concentric-square diptych, *Jasper's Dilemma*, which also juxtaposes a coloured left panel with a grey-scale right panel.

I think *River's Edge* does touch on the idea of multivalent as opposed to binary systems, as you suggest. However, it has a more immediate resonance in my personal fascination with the difference between full-colour and grey-scale images, which operate simultaneously as separate nuanced languages in our graphic culture.

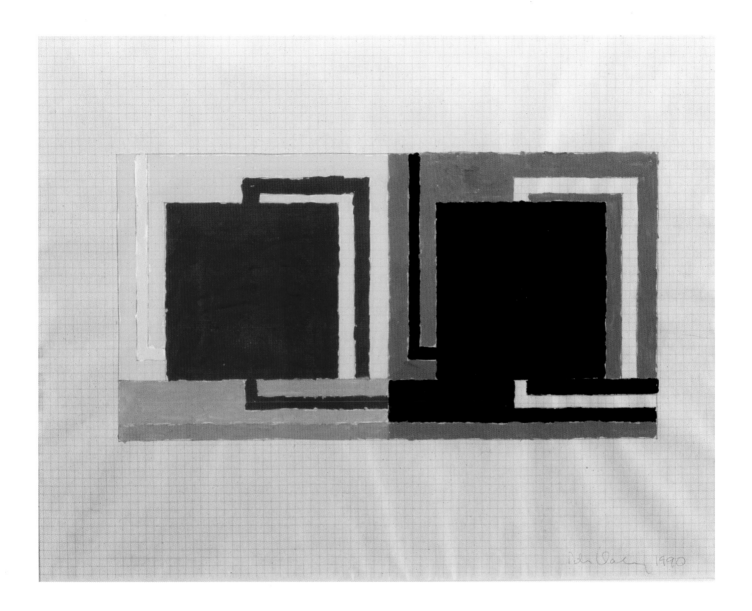

MM: How does the interactive network of colour, light, geometric shapes and patterns form the elements of the imaginary or theoretical world of your paintings? How does it resemble or differ from the self-organising system of the brain or the architecture of artificial intelligence and neural networks?

PH: The increasing complexity in my images over the years can well be compared to complexities that might be created by artificial intelligence systems. For me, however, it is essential to note that such artificial intelligence systems are, in fact, only arbitrary systems. While they may approximate certain kinds of intellectual processes, they in no way reflect the full mystery of human thinking, which is the product of not just the neurones of the brain but of the experience of the senses and the body on which the brain is always dependent.

My work, as a whole, attempts to represent late-twentieth-century systems of communication and organisation. I still feel, as I did in the 1980s, that I am presenting, in the arena of art, images of a pervasive system whose reach is too seldom acknowledged as determining the parameters of our thinking, movement and social relations.

I imagine that I paint these images with as much intensity as I can in order to give the paintings and what I depict as much immediacy and emotional urgency as possible.

MM: How has our modern society and its economy changed as a result of advances in information technology since the 1980s? How has it effected our thoughts and behaviour? How has it influenced your thoughts and the construction of your paintings?

PH: There was a time in the mid-1980s when I found myself and some of my colleagues branded as misguided theory-geeks. Yet so much of what was discussed then has come to pass. Representation has been wrested from reality throughout the culture. Simulation is an accepted part of high-tech movie-making and television commercials. Appropriation has turned into 'sampling', as the notion of authorship has changed in the world of pop music.

I feel fortunate to be working during a time of such profound revolution in communication. In 1980, the fax machine had just appeared. Today we are at the beginning stages of the creation of a worldwide network of computer-based communication. I view this development with both fascination and trepidation. Since 1980, my images seem, step by step, to have grown more complex and fast-paced in a way that somehow parallels the acceleration of the movement and information in the new computer culture. I take great pleasure in the idea that my work could be a mirror of this era of change.

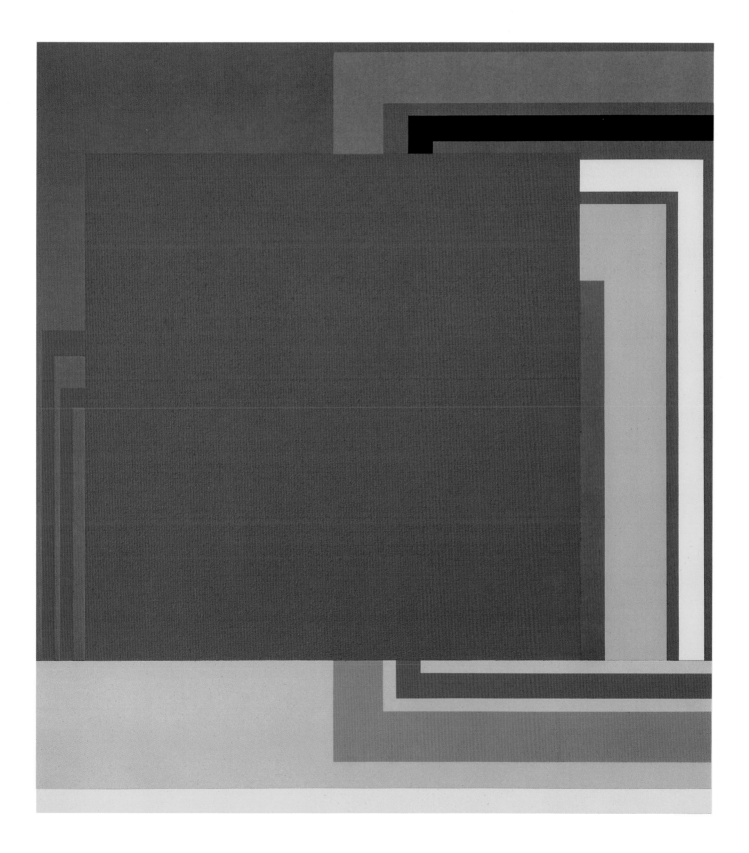

HALLEY, Peter
Rob and Jack, 1990

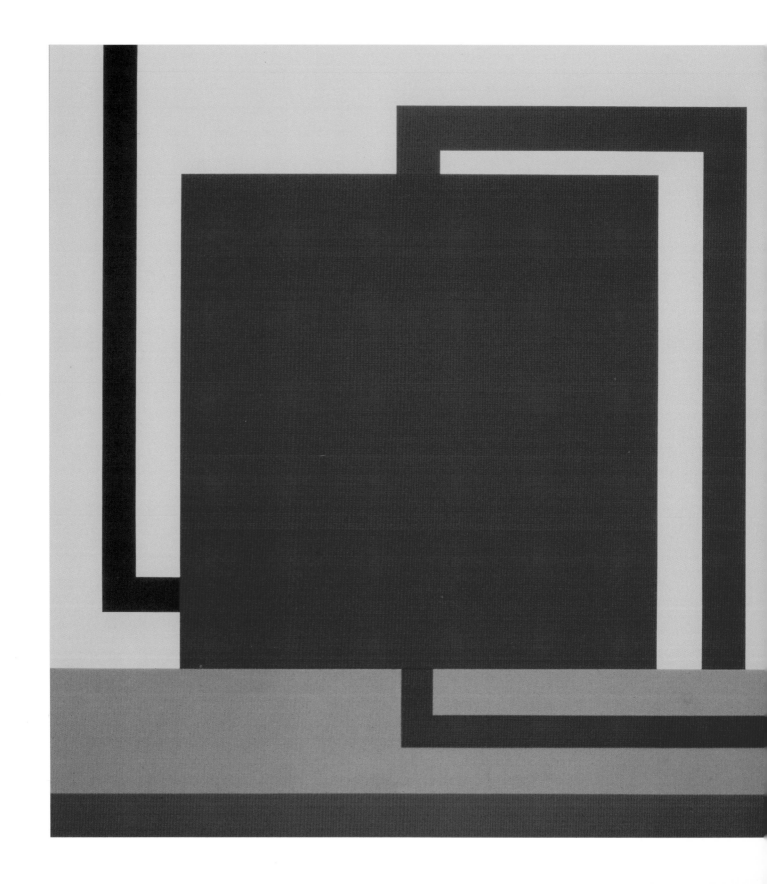

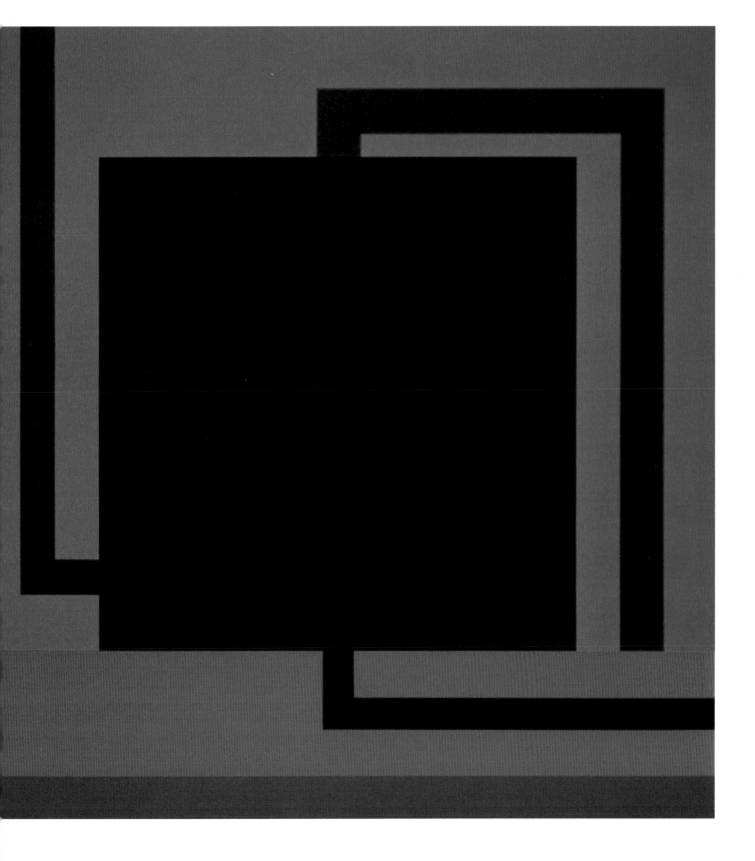

JEFF KOONS

MM: How has your personal life been reflected in your works? Are they sometimes about your feelings, hopes and desires?

JK: I believe that every artist's work reflects the subjectivity of his or her life experiences. No matter how much the artist strives to have as objective a vocabulary as possible, the seeds of communication are from the artist's past. From the time I was a child, my desire for art to supplement my desires, hopes and feelings must be evident in my work.

MM: How has your experience in a commodity firm effected your views or concerns about art and how has it influenced your art?

JK: My experience with sales has led me to appreciate the moral freedom of the artist. That is, being able to take advantage of tools of communication but maintain a moral position of not demanding anything from the audience.

MM: How has American culture changed since the 1980s, and how have your concerns in making art developed and changed?

JK: I believe that American artists were seen as being very cynical in the 1980s. To the contrary, I believe that the rest of culture was being cynical and that the art world was being honest. If anything has changed within my own habits of art making since the 1980s, it is the appreciation of the luxury artists have within society to participate culturally but to also maintain anonymity.

'*Woman in Bath Tub* was based on a postcard. This was part of my total vocabulary on Banality. It was to show the interface between the Victim and the Victimiser. There's the snorkel and somebody is doing something to her under the water because she's grabbing her breasts for protection. But the viewer also wants to participate and victimise her.'
JEFF KOONS

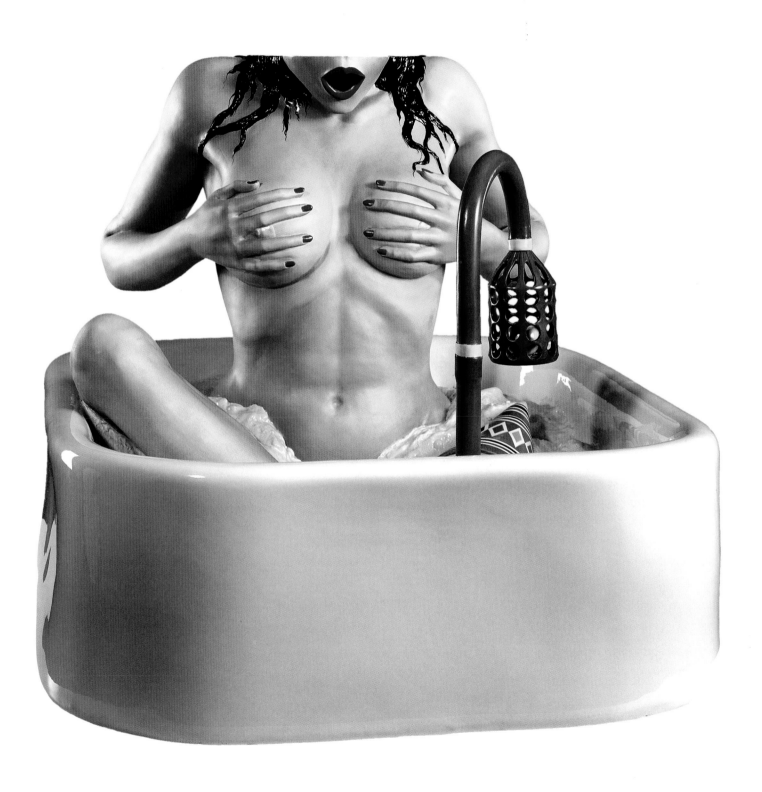

KOONS, Jeff
Winter Bears, 1988

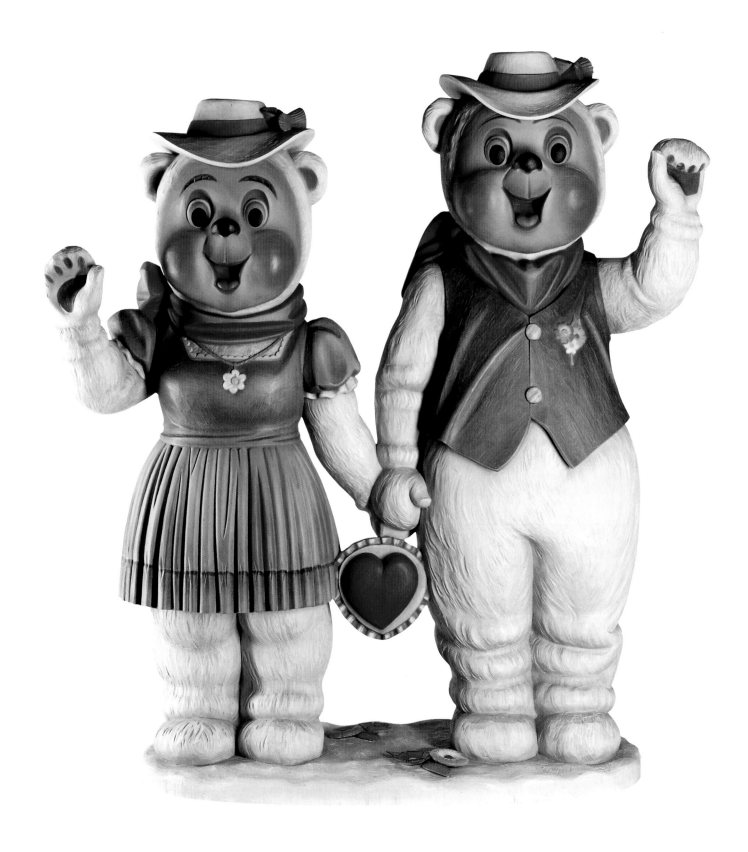

CARROLL DUNHAM

MM: When I first saw your painting, I remembered the words from a title of a painting by Gauguin, *Where Do We Come From? What Are We? Where Are We Going?*(1897). Whereas art and culture have changed throughout history, the tendencies of modern human nature have changed little throughout our evolution. How are you influenced by the making of our society and the characteristics of the human race, and what are your concerns in making your paintings?

CD: Interesting art always attempts to connect the personal and the universal. Individuals can't escape the influence of their culture, but are each specific expressions of the larger conditions of 'human nature'.

MM: Many artists have tried to explore the human subconscious in their paintings. What have you learned from their mistakes and experiences, as well as your own mistakes and experiences?

CD: Every 'mistake' leads to the next re-definition of 'understanding'. The unconscious mind rules art.

MM: When you begin to work on a surface, where does the procedure and structure come from? How has your painting evolved and changed since the 1980s and how has it stayed the same?

CD: I think about material and formal structures far more than subject-matter or story line. For that reason, I always feel that I'm doing the same thing.

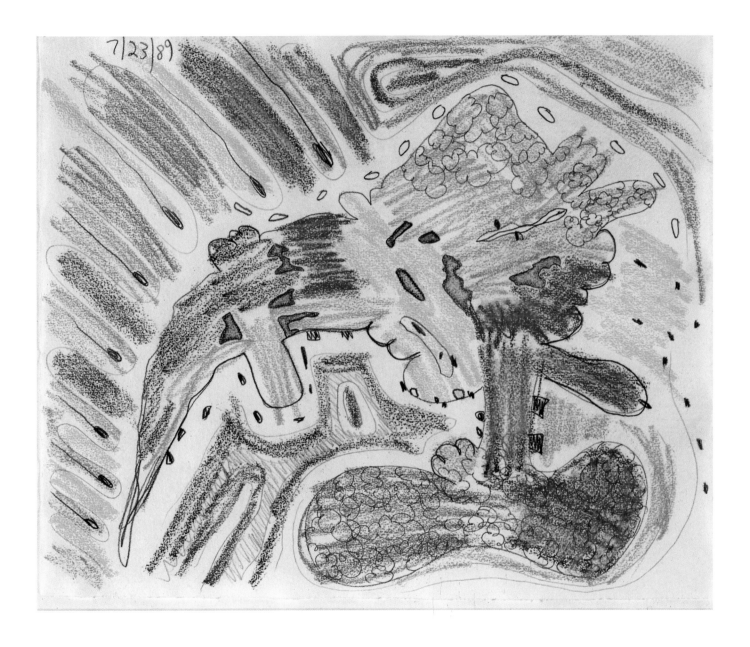

DUNHAM, Carroll
Floating Shape, 1989–90

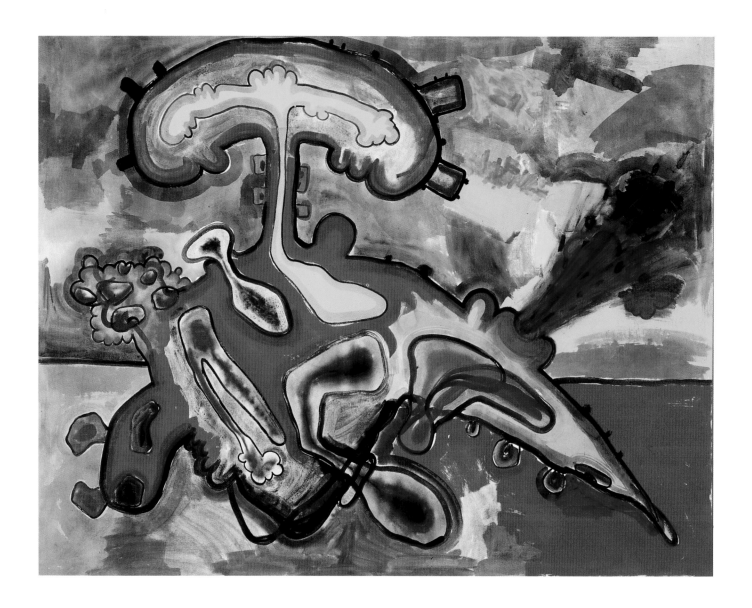

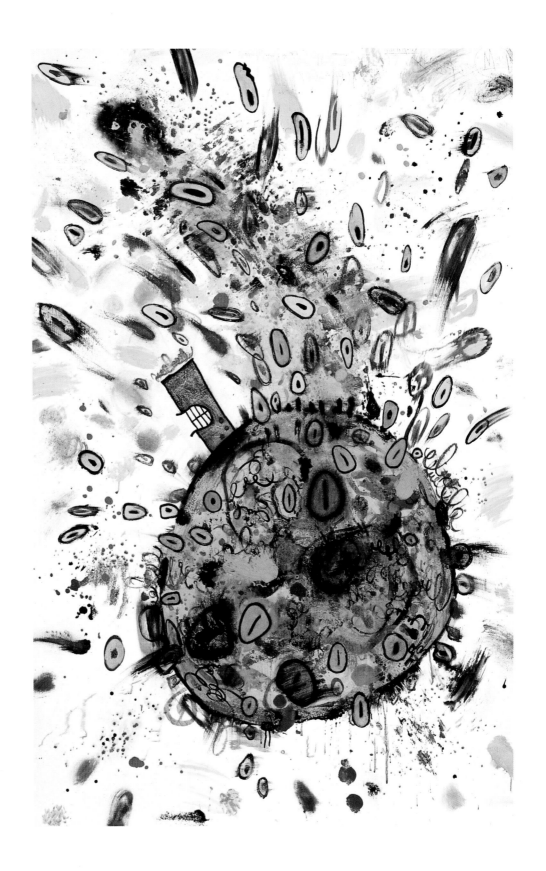

DUNHAM, Carroll
Shape with Entrance, 1990

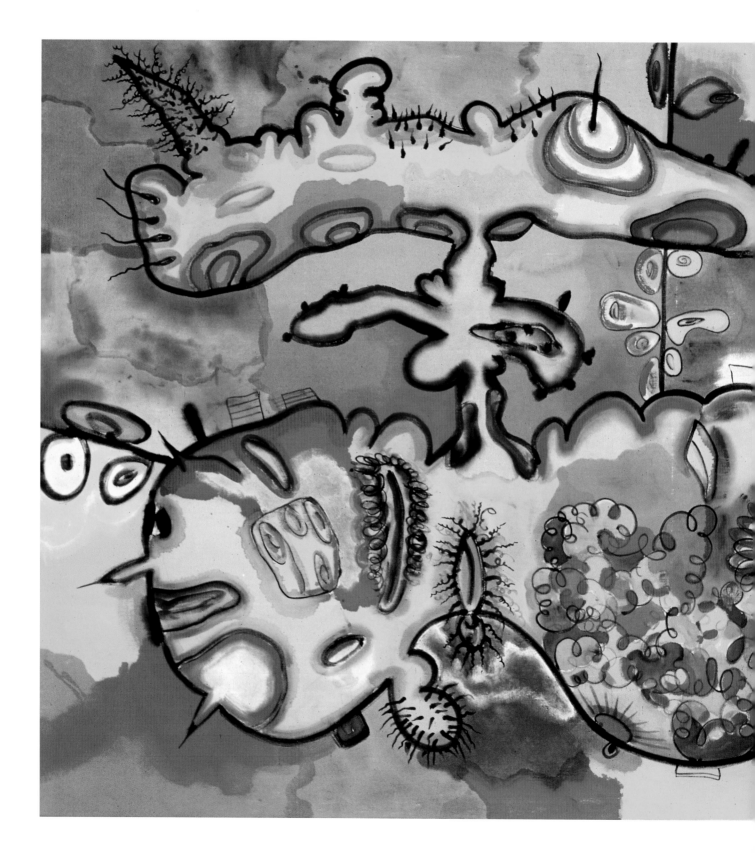

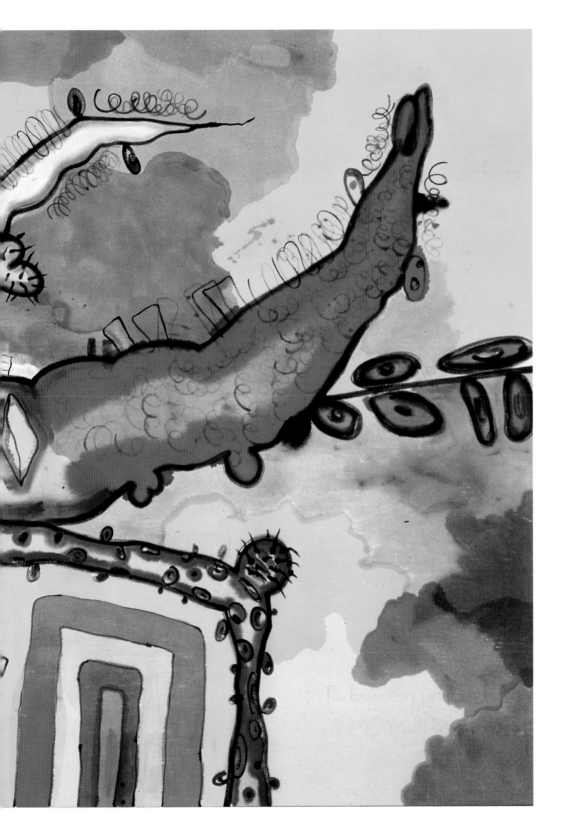

ALEXIS ROCKMAN

MM: What experience do you want to express and share in your paintings?

AR: My work has been about examining a culture that is extremely ambivalent about its biological contract with the rest of this planet.

MM: In the organization of your paintings, have you been influenced by Charles Darwin's theory of evolution, or Sigmund Freud's findings on the relationship between the conscious and the unconscious forces of the mind? Are there relationships that you express between psychology and biology in your paintings?

AR: Absolutely, and I also believe that when I first started to make my works, I arrived at my imagery at a much more intuitive level. As my work progressed, I realized that it would enrich my experience of making the work to conduct research about the iconography with which I was dealing. I think that most animals, other than domestic and farm animals, are both threatening and frightening. They undermine our fragile perception that we have a level of control over our landscape and that we are outside the cycles that govern other organisms.

MM: What are the processes in making your paintings? Are your paintings planned logically or do they evolve like biological systems?

AR: My body of work is a series of loosely connected projects that investigate how humans perceive nature. They are highly planned.

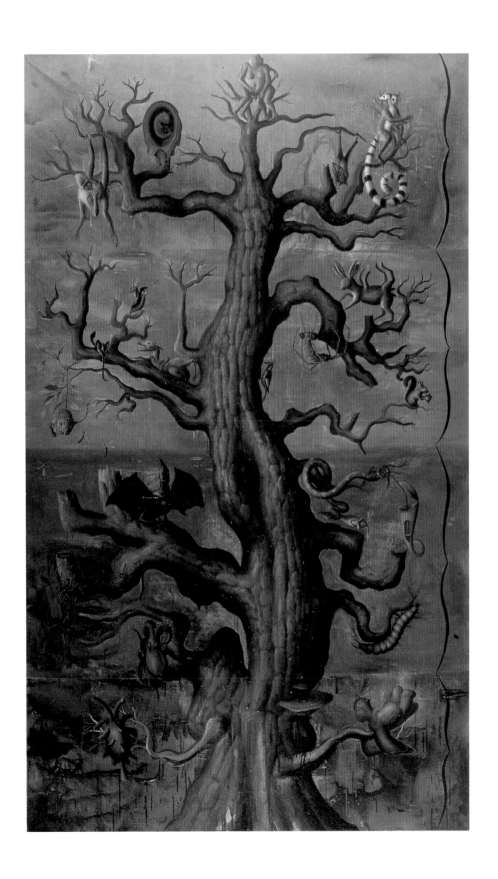

ROCKMAN, Alexis
Untitled, 1988

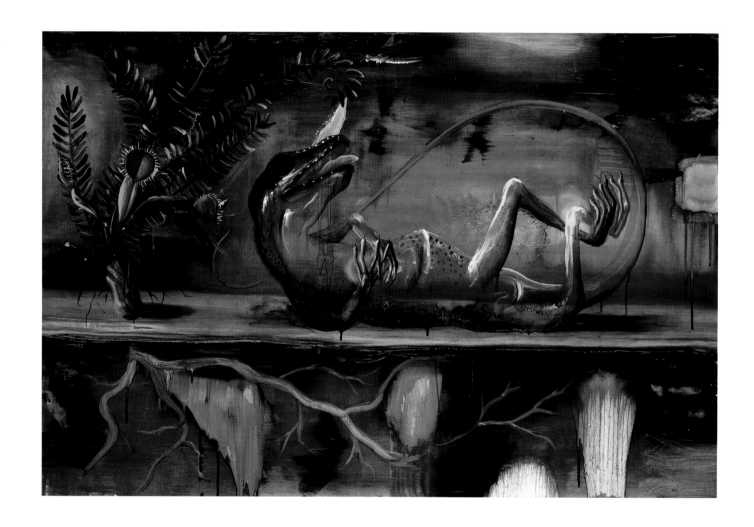

TIM ROLLINS

MM: What has been the most rewarding aspect of your work with your students making art?

TR: While it is very exciting whenever we complete what we all believe is a successful and convincing work of art, it is the day-to-day, sometimes exhilarating, usually grinding process of making art that gives us all the most satisfaction. It is the bottomless struggle of conceiving, researching, planning, producing and exhibiting our work – and the transformation of our thinking and lives in the process – that justifies the making, no matter what the outcome. Although arriving at the final destination of the finished artwork is thrilling, we are more grateful for experiencing the journey itself.

MM: How has your work with the young artists of K.O.S. changed your life and theirs?

TR: Everyone in the group, including myself, comes from what I call a culture of impossibility. At an early age, your life expectations are determined more by what you can't do than what you can. In the realm of art, however, the only impossibility is impossibility itself. The entire K.O.S. experience has transported all of us together from a place of fantasy (that we could be artists) to dream (that we will be artists) and to fact (that we are artists.) College and university educations are no longer unrealistic wishes, they are inevitable realities. In part, because of the success of our art and our transcending of stereotypes, our home base in the South Bronx has risen from ruins to renaissance. When children are changed, families are changed. When families are changed, communities are changed. When communities are changed, the nation is changed. And when the nation is changed, the world is changed. We now know that no matter what our past, present or future circumstances, through art we have a material and ringing collective voice – like a choir eternal – that will always have a place and a presence, even in a largely dismissive, deaf and hostile culture.

MM: How do you view the American art, culture and society of the 1980s?

TR: I'm very much against a model of history that links decades together as if they were a line of railroad cars running on the tracks of time. Time is not a train, it is a river – living water flowing continuously. That said, I can only remember what the period felt like back then. The great irony working in the South Bronx in the 1980s was that while the physical, psychological, emotional and spiritual environment of the neighbourhood was at its most pathological, its cultural moment was at its zenith. The creation and swift explosion of hip-hop culture in vernacular music, dance, visual art, poetry and fashion continues to transform popular culture internationally. I recall the ethos of the moment as celebratory.

For the marginalized, you had to celebrate each new day to the full and by any means necessary simply to remain sane and to survive. For the educated, élite and privileged under the Reagan years, folk celebrated – particularly through the production and acquisition of fine art – their escape from the dreary post-war, civil rights and recession traumas of the 1970s. The whole period was electric with contradictions and the time could be titled 'When Worlds Collide'. Uptown fell onto downtown. Downtown was lifted uptown. The art of the time shared the contrariness of the time. Work was vernacular yet rarefied, romantic yet unsentimental, surreal yet clearly true-to-life, organic yet over-determined, conceptual yet spectacular, fantastic yet strangely antiseptic, hilarious yet as serious as AIDS, with almost everything bearing an extremely anxious and insecure kind of beauty.

MM: How does your art reflect this period?

TR: Like those days, our work is deeply synthetic and profoundly American. By that I don't mean artificial, our art is synthetic in that it melds together a great myriad of disparate ideas, practices, traditions and forms for the creation of something new and surprisingly whole. By painting on pages torn from classics of world literatures, pages torn from a canon considered distant and irrelevant to us, all manner of borders are crossed. Pages glued onto linen produce a field that becomes both the modernist grid and the battleground of meaning upon which our painted images appear and clash with defiance, joy, determination, dread and, hopefully, some kind of victory.

ROLLINS, Tim + K.O.S.

Untitled, 1989

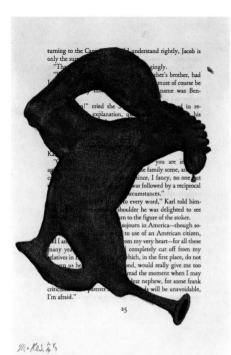

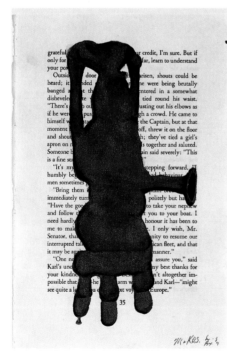

'All animals are equal,
but some animals are
more equal than others.'
GEORGE ORWELL
Animal Farm

Anatomy of Power

When I saw the painting by Tim Rollins & K.O.S. *Animal Farm I 1985–88*, it caused me to think about the possibility of doing series of paintings to represent events and experiences by observing the development of the world since the 1980s.

It was an interesting time, with the globalisation of world economies and the bourgeois material revolution of the decade. Following the end of the Cold War came the fall of the totalitarian regimes of the East and the disintegration of the Soviet Union, the dominance of the Western powers and America as the sole superpower.

In an attempt to fuse artistic and political purposes in a visual expression of the literary work of George Orwell, *Animal Farm*, I communicated to Mr Rollins many ideas that interested me. Following discussions with members of K.O.S., Mr Rollins co-ordinated their efforts and creativity to form a series of three potent paintings representing their collective experiences.

While the three paintings together would become an inter-related triptych, each painting is a complete and independent work on its own

The G7 as an industrial and political forum of power and the globalisation of world economies.

WHO	WHAT	WHY
Title	G7	The group of seven leading industrial nations: the United States, Japan, Germany, France, the United Kingdom, Italy and Canada
Reagan	Cock	Appearance, the way he groomed his hair
Thatcher	Goose	The K.O.S. chose it, the way she held her head high
Mitterrand	Turkey	His character as the proud and long-serving President of France
Köhl	Bull	The strong economy of Germany, a large and strong animal
Mulroney	Racoon	An animal associated with Canada
Andreotti	Cock	Because of the corruption amongst politicians in Italy, where the chickens were being thrown from the barn
Kohl	Horse	From Gericault's *Horse frightened by Lightning*, the strong economy of Japan yet fearful of its own stability
	Windmill	The manufacturers and the industrial power of the G7 nations
	Hammer	The working labour in industrial countries
	3 corn cobs	An important agricultural commodity and seen in the landscape of most American farms
	3 corn seeds	Different colour seeds representing a diversity of people in colour, race and future generations

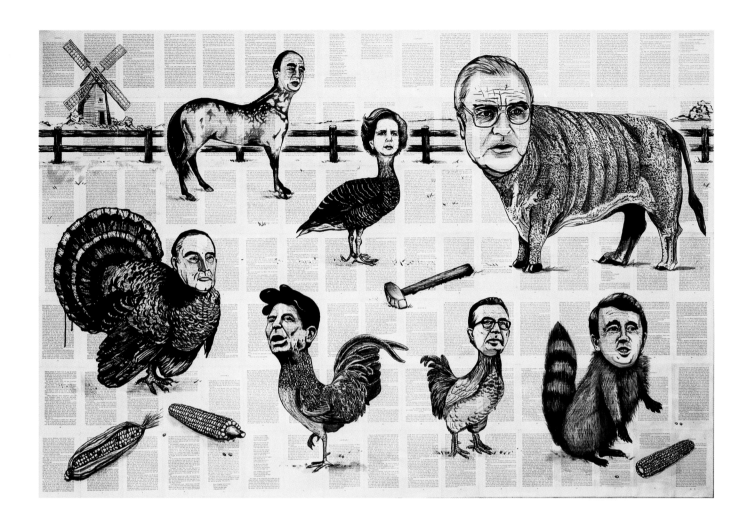

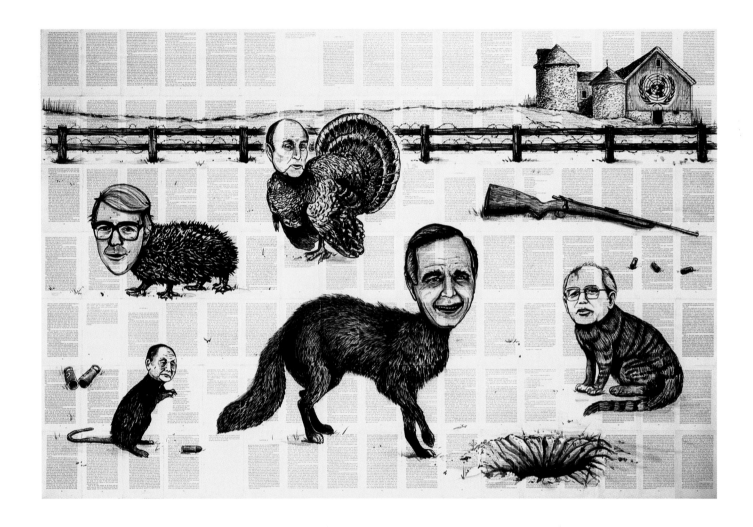

The UN Security Council as a political and military forum of power and the dominance of the Western powers with American leadership. The fall of the totalitarian regimes of the East and the end of the Cold War.

WHO	WHAT	WHY
Title	The New World Order	UN Permanent Security Council members: the United States, France, the United Kingdom, the Soviet Union and China
Bush	Fox	From the fable of the fox and the hedgehog, the leaders can be compared to the fox, who knows many little things, and the hedgehog, who knows a few big things
Major	Hedgehog	
Mitterrand	Turkey	His character as the proud and long-serving President of France
Gorbachev	Cat	The last leader of the Soviet Union, observing its disintegration
Den Xiaoping	Rat	From the Chinese horoscope Year of the Rat
	Gun	The Persian Gulf War and a sign of military power
	Barbed wire	The Persian Gulf War
	3 bullets	The Tianamenan Square demonstration
	3 bullets	The last Soviet Union coup
	Fox hole	The Persian Gulf War from the drawing by Otto Dix
	Farm house	The UN, where the grain storage resemble missile silos
	UN emblem	On the house in which the UN was at war

The 'Big Three', the disintegration of the Soviet Union and America's domination as a world superpower in the military, economic and cultural arenas.

WHO	WHAT	WHY
Title	Big Three	The three biggest economies: United States, Japan and Germany
Kohl	Bull	Smaller bull, the weaker economy of Germany and also Kohl's large individual appearance
Clinton	Horse	The strong and proud economy of America and Clinton as the first President of America post-Cold War, as the only superpower
Miyazawa	Goat	The Japanese economy needed to survive during harder times
	Bees	The working class and also the number of members of K.O.S.
	Bee hive and the milk can	Wealth and economic power in the land of 'milk and honey'
	Spilled milk	The contours of what was the Soviet Union
	Sunflower	From the drawing by Van Gogh and a new dawn
	Sunflower seeds	Oil seeds, the important crop, subject to the trade tensions in the General Agreement on Tariffs and Trade between America and Europe
	Tractor	Ploughing the land in a business cycle of production
	Ford	Ford motor company, one of the largest American manufacturing companies; corporations are the real power in the world
	Smoke	Burning of fuel and the oil that runs the economies
	The man	The solitude of man

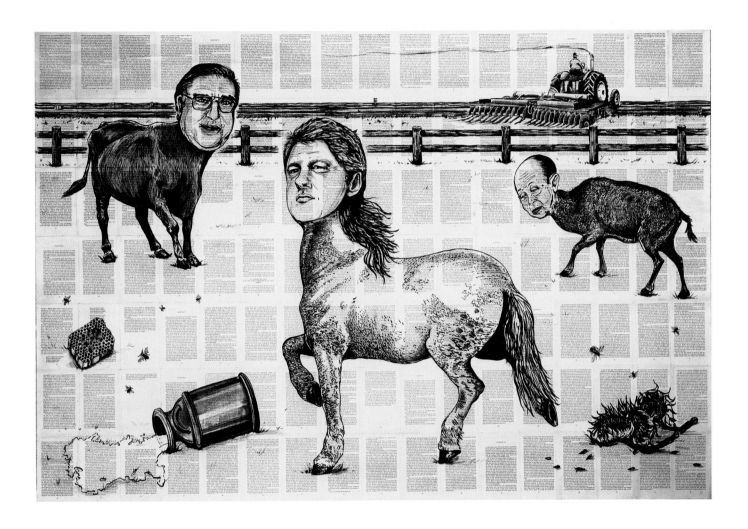

STEINBACH, Haim
Untitled (Cabbage, Pumpkin, Pitchers), 1986

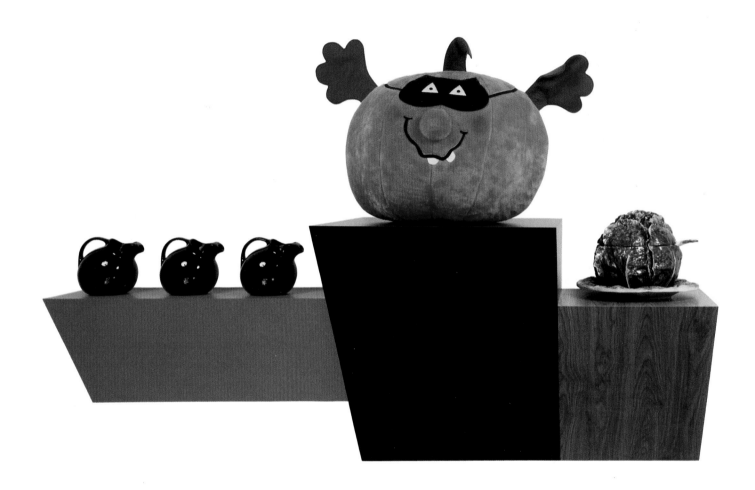

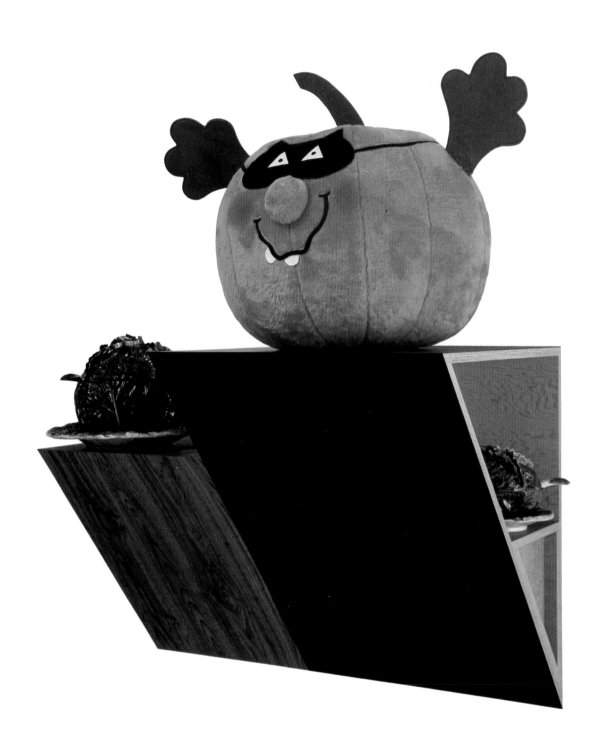

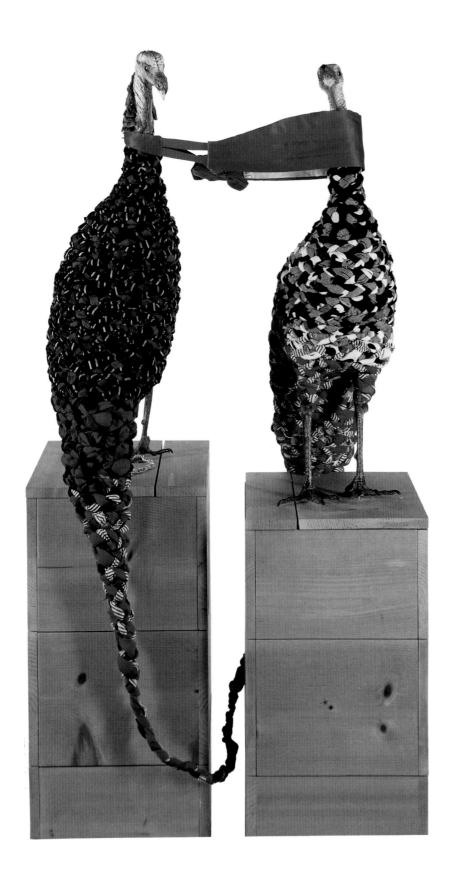

CAIN, Peter
Porsche, 1989

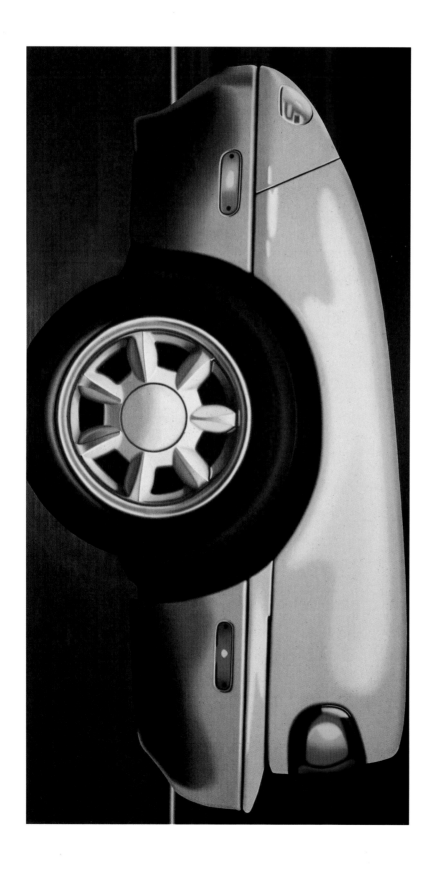

CAIN, Peter
Porsche, 1989

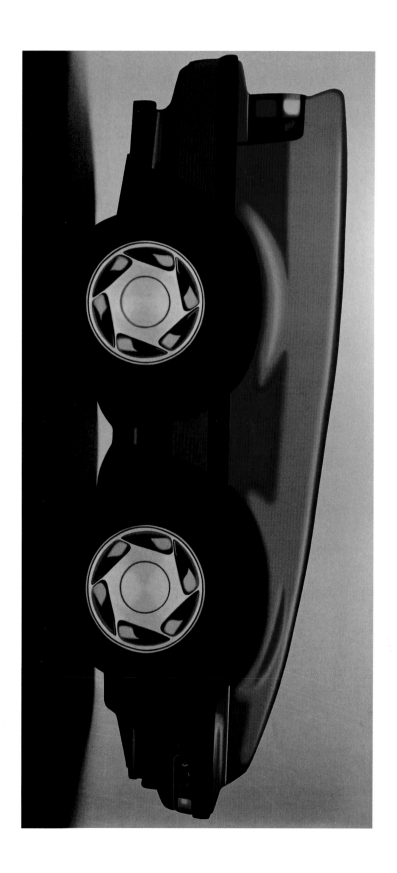

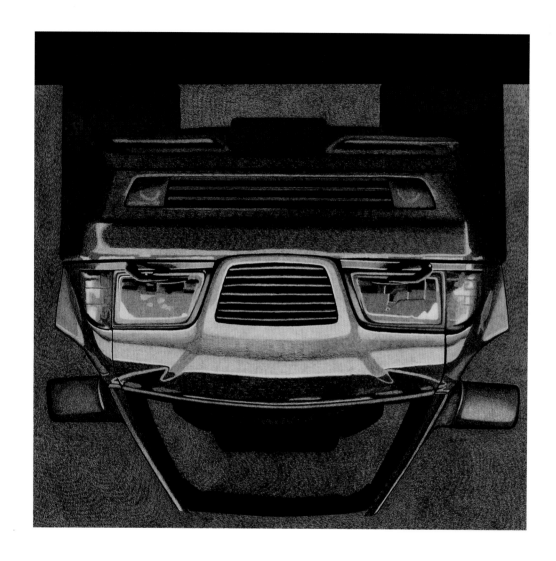

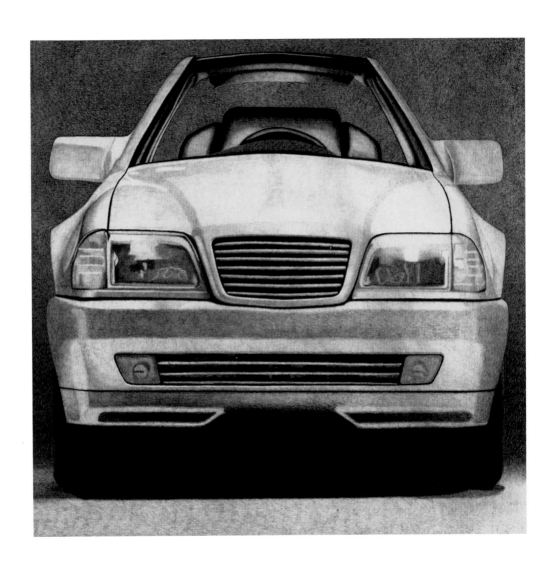

STEPHAN, Gary
They Are and We Can ©, 1987

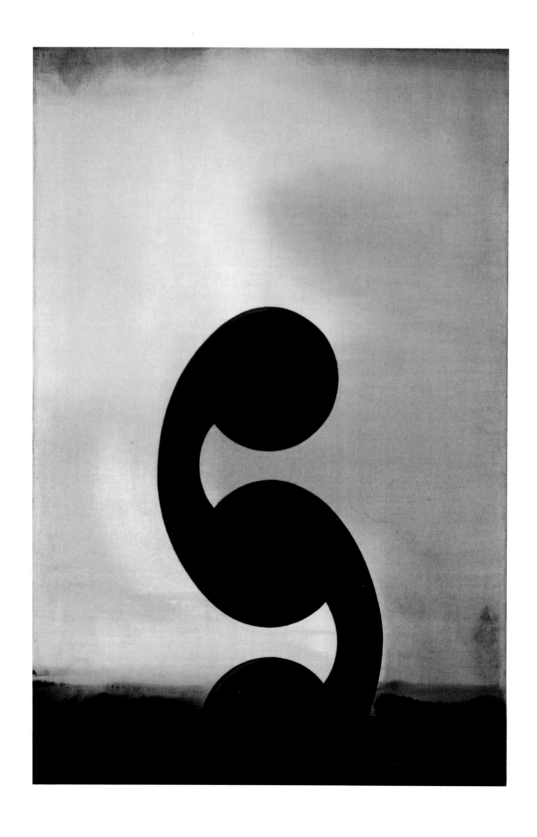

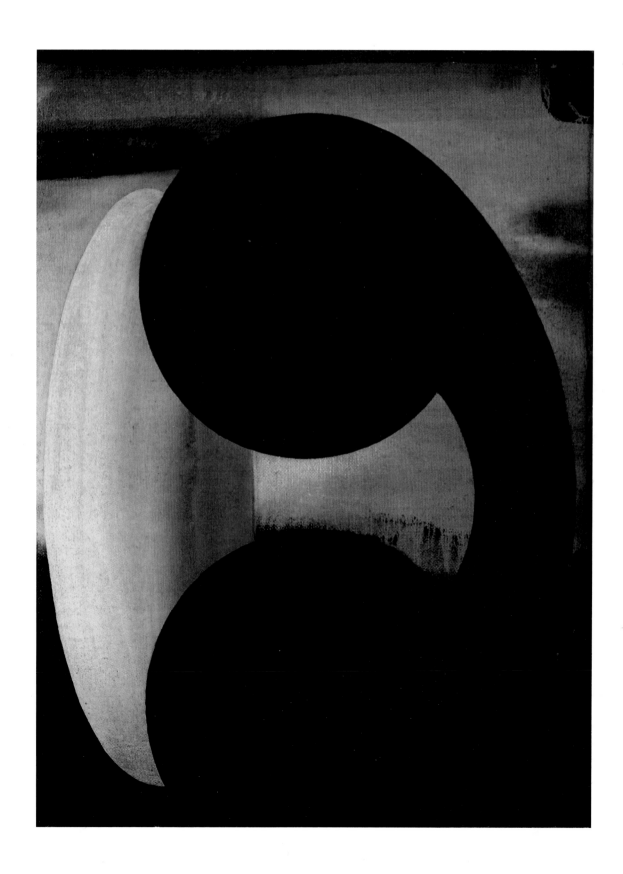

NAGY, Peter
Microbe, 1987

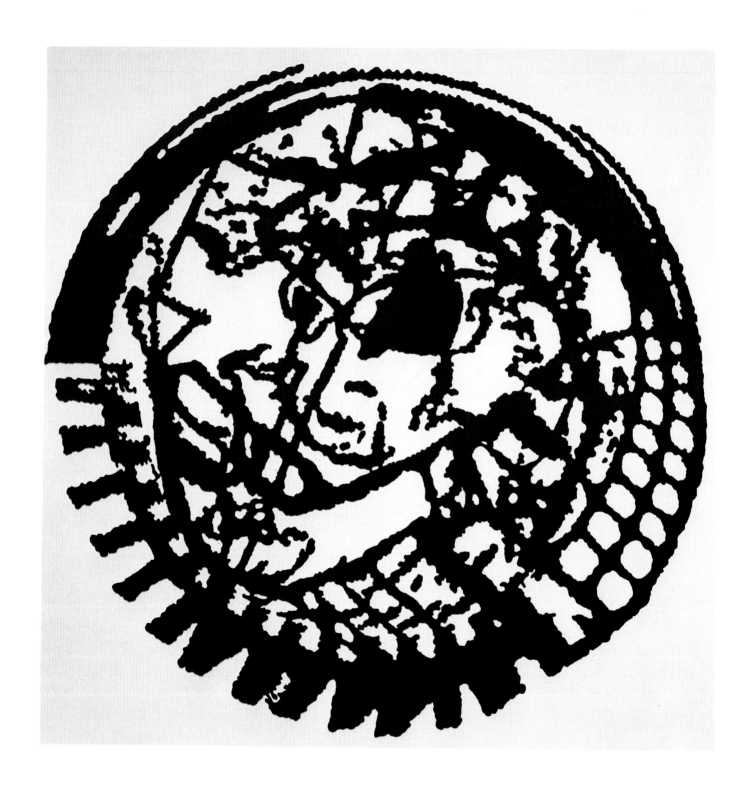

BLAKE, Nayland
Vitrine, 1990

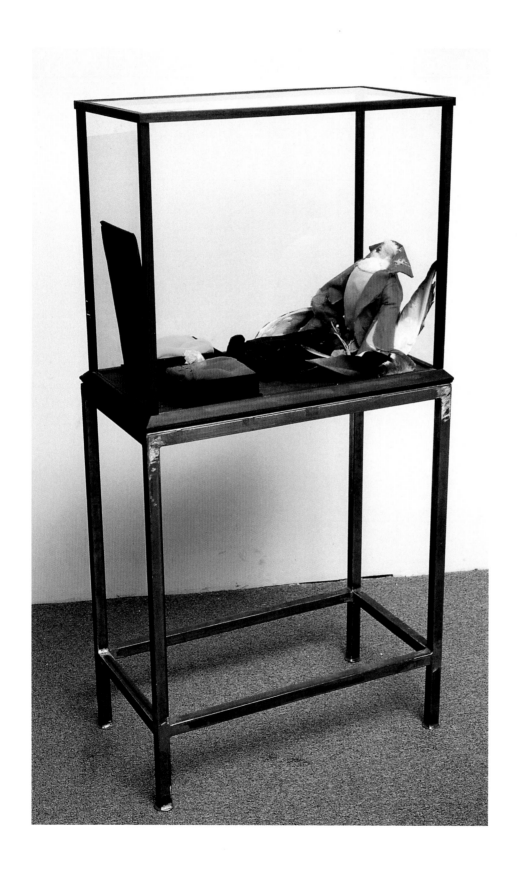

BECKLEY, Bill
Post Fear 7, 1987

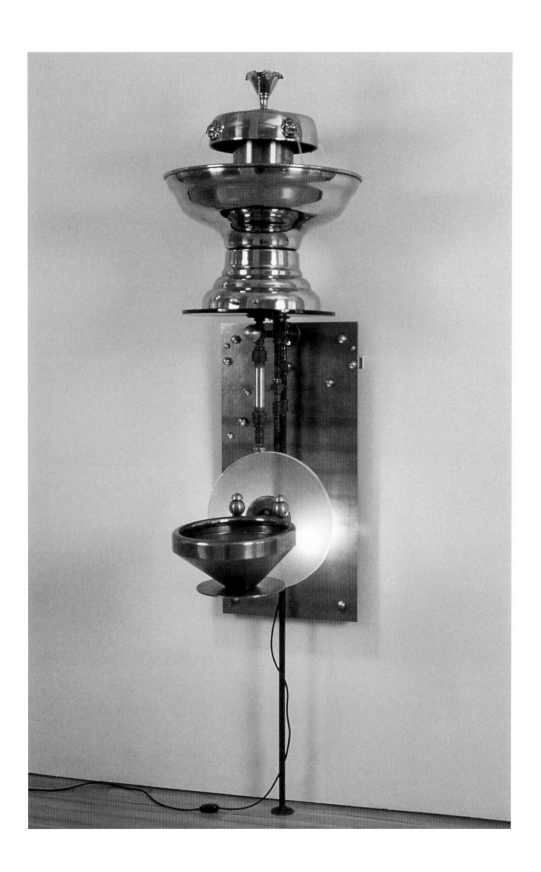

SHERMAN, Cindy
Untitled # 152, 1985

SIMMONS, Laurie
English Lady, 1987

HOLZER, Jenny
Selection from the Survival Series (In a Dream I Saw...), 1983–85

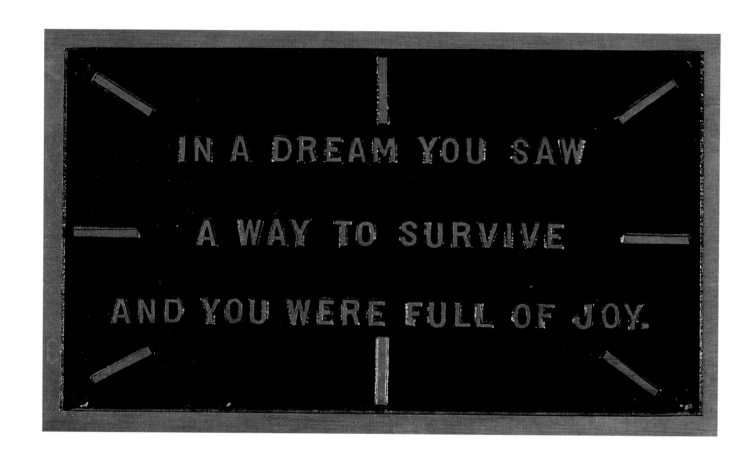

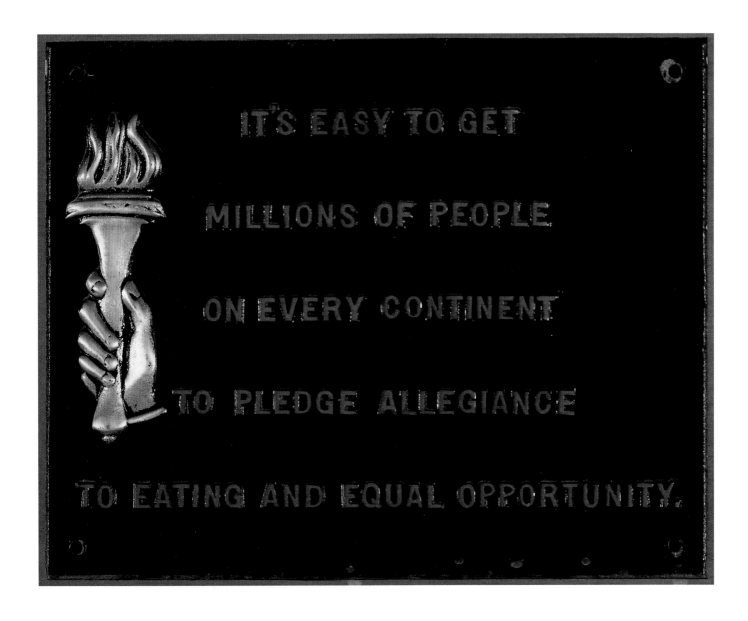

KRUGER, Barbara
Untitled (I've Seen This Movie Before), 1986

CHARLESWORTH, Sarah
Heart's Retort, 1987

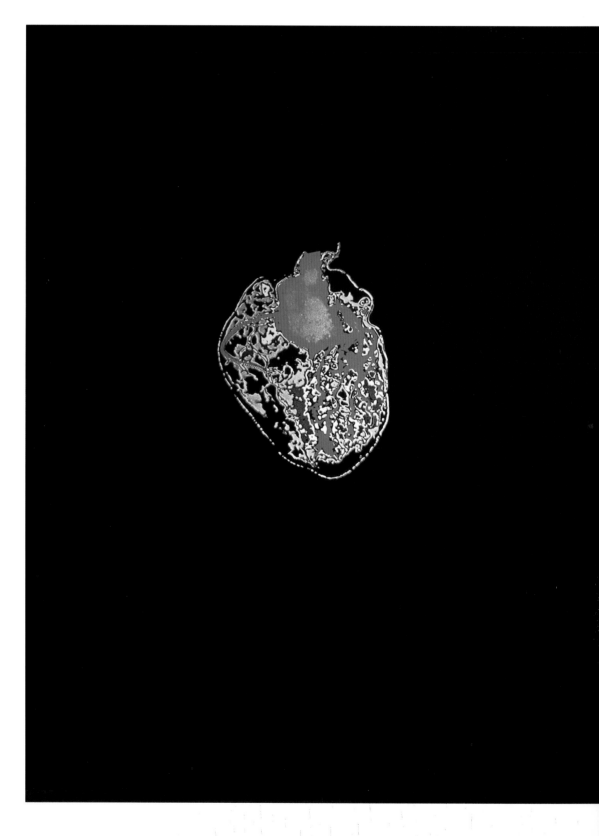

CHARLESWORTH, Sarah
Green Mask, 1986

WARHOL, Andy
Untitled, 1981

LANDY, Michael
Appropriation 1, 1990

LANDY, Michael
Appropriation 3, 1990

HUME, Gary
Dolphin Painting, No. IV, 1991
The Saatchi Gallery, London

COLLISHAW, Mat
Ideal Boys (John Luca & Paco), 1997

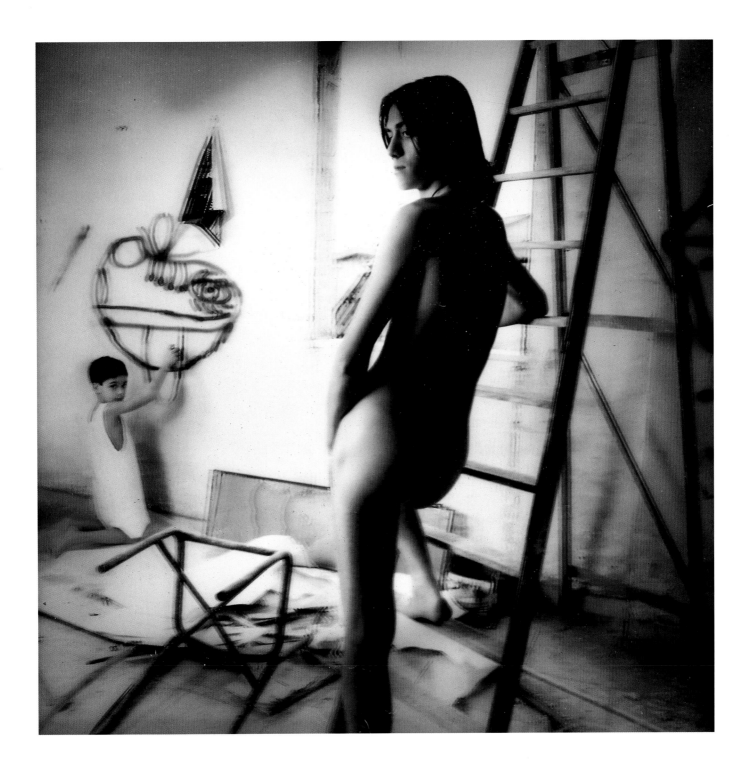

COLLISHAW, Mat
Ideal Boys (Roberto), 1997

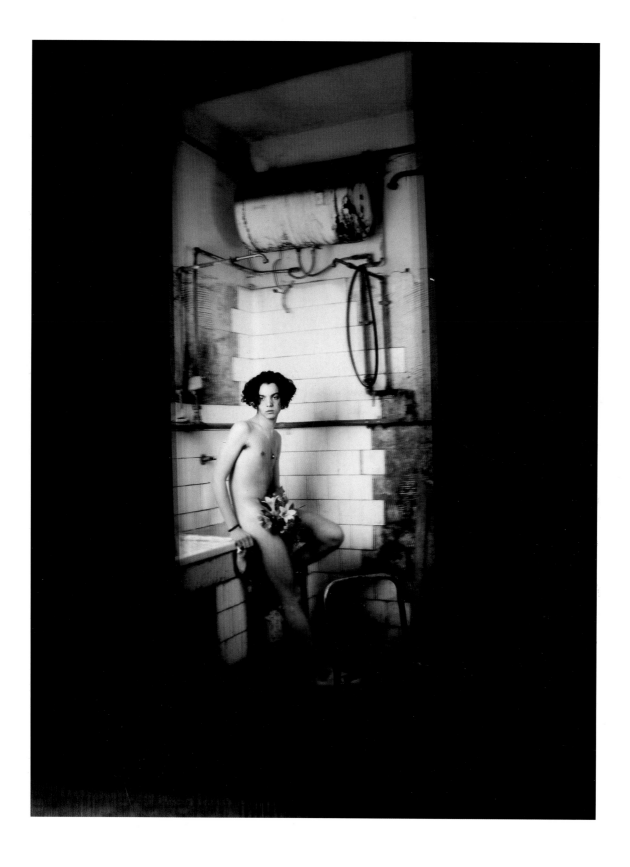

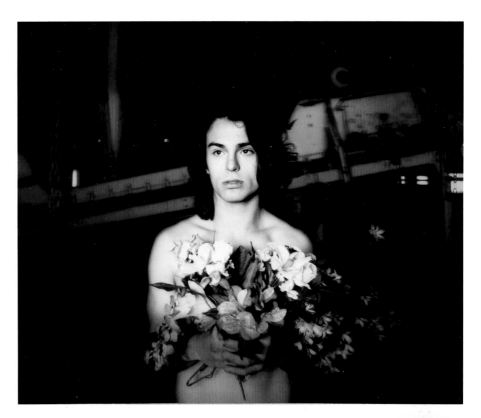

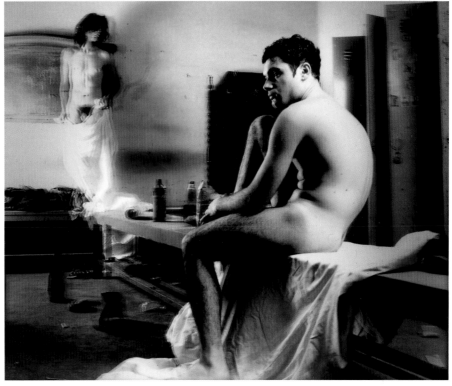

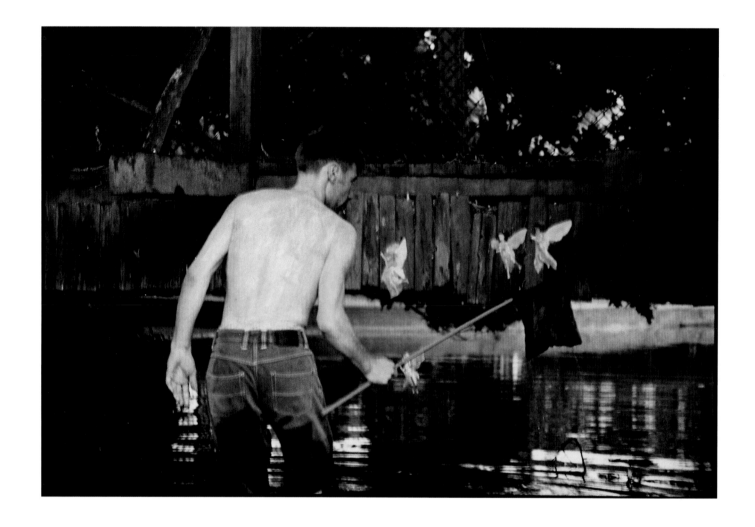

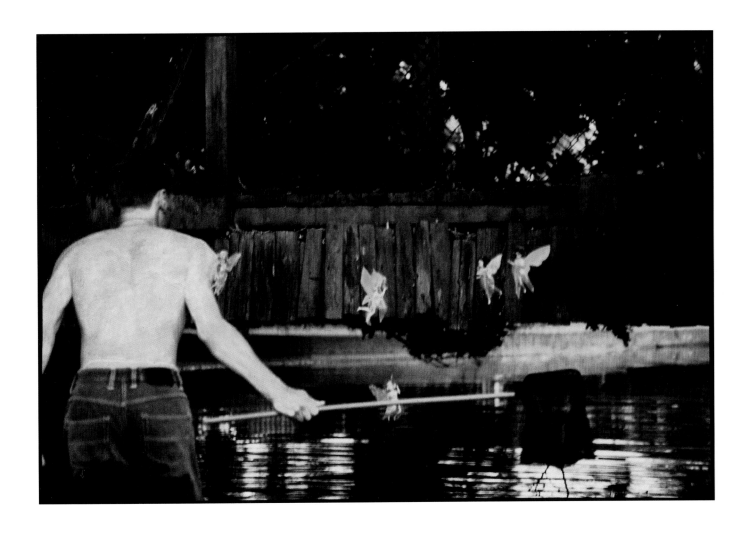

COLLISHAW, Mat
Morning Toilet, 1996

COLLISHAW, Mat
Morning Toilet, 1996

CATALOGUE OF WORKS

BILL BECKLEY (b. 1946)

Post Fear 7
[p. 80]
Painted wood construction
40½ × 16½ × 7in (102.8 × 41.9 × 17.8cm)

Executed in 1987

PROVENANCE: Tony Shafrazi Gallery, New York

NAYLAND BLAKE (b. 1960)

Vitrine
[p. 78]
Mixed media in vitrine
52 × 25½ × 14in
(132.2 × 63.5 × 35.6cm)

Executed in 1990

PROVENANCE: Michele Wilcox Gallery, San Francisco

PETER CAIN (b. 1959)

Porsche
[p. 60]
Oil on canvas
90 × 49in (228.6 × 124.5cm)

Painted in 1989

PROVENANCE: Karsten Schubert Ltd., London

EXHIBITED: London, Karsten Schubert Ltd.,
'We've lost ET but the boy's coming back:
Peter Cain, Michael Jenkins, Michael Landy',
November 1991.
London, Institute of Contemporary Art, 'The
Institute of Cultural Anxiety, Works from the
Collection', December 1994–February 1995
(illustrated in the catalogue in colour).

Red Prelude # 2
[p. 61]
Oil on canvas
102 × 48in (259 × 121.9cm)

Painted in 1990

PROVENANCE: Daniel Weinberg, Los Angeles

500 SL # 2
[p. 62]
Graphite on paper
19½ × 20in (49.5 × 50.8cm)

Executed in 1991

PROVENANCE: Karsten Schubert Ltd., London

EXHIBITED: London, Karsten Schubert Ltd.,
'We've lost ET but the boy's coming back:
Peter Cain, Michael Jenkins, Michael Landy',
November 1991.

500 SL # 3
[p. 63]
Graphite on paper
19½ × 20in (49.5 × 50.8cm)

Executed in 1991

PROVENANCE: Karsten Schubert Ltd., London

EXHIBITED: London, Karsten Schubert Ltd.,
'We've lost ET but the boy's coming back:
Peter Cain, Michael Jenkins, Michael Landy',
November 1991.

SARAH CHARLESWORTH (b. 1947)

Heart's Retort
[pp. 90 and 91]
Laminated c-print with lacquer frame
40 × 60in (101.6 × 152.3cm)

Executed in 1987, this work is from an
edition of 4

PROVENANCE: Jay Gorney Modern Art Ltd.,
New York

LITERATURE: 'Media Post Media', New York
1988 (another from the edition illustrated in
colour).
'A Forest of Signs: Art in the Crisis of
Representation', Los Angeles 1989 (another
from the edition illustrated in colour, p. 80).

Green Mask
[p. 92]
Laminated c-print with lacquer frame
40 × 30in (101.6 × 76.3cm)

Executed in 1986

PROVENANCE: Jay Gorney Modern Art Ltd.,
New York

MAT COLLISHAW (b. 1966)

Ideal Boys (John Luca & Paco)
[p. 102]
3D colour transparency and perspex in
metal light box
22 × 24 × 3½in (55.5 × 61 × 9cm)

Executed in 1997, this work is from an
edition of 3

PROVENANCE: Karsten Schubert Ltd., London

LITERATURE: J. Thompson, 'Mat Collishaw',
Breda 1997 (another from the edition
illustrated in colour, p. 57).

Ideal Boys (Salvatore & Paco)
[p. 103]
3D colour transparency and perspex in
metal light box
12 × 12 × 3in (30.5 × 30.5 × 7.5cm)

Executed in 1997, this work is from an
edition of 3

PROVENANCE: Karsten Schubert Ltd., London

Ideal Boys (Roberto)
[p. 104]
3D colour transparency and perspex in
metal light box
12 × 10 × 3in (30.5 × 25.5 × 7.5cm)

Executed in 1997, this work is from an
edition of 3

PROVENANCE: Karsten Schubert Ltd., London

LITERATURE: J. Thompson, 'Mat Collishaw',
Breda 1997 (another from the edition
illustrated in colour, p. 55).

Ideal Boys (Francesco)
[p. 105]
3D colour transparency and perspex in metal
light box
12 × 16 × 3in (30.5 × 40.7 × 7.5cm)

Executed in 1997, this work is from an
edition of 3

PROVENANCE: Karsten Schubert Ltd., London

Ideal Boys (Francesco & Gennaro)
[p. 105]
3D colour transparency and perspex in
metal light box
18¾ × 24 × 3½in (47.5 × 61 × 9cm)

Executed in 1997, this work is from
an edition of 3

PROVENANCE: Karsten Schubert Ltd., London

LITERATURE: J. Thompson, 'Mat Collishaw',
Breda 1997 (another from the edition
illustrated in colour, p. 56).

Untitled
[p. 106]
Cibachrome print
10 × 13¾in (25.4 × 33cm)

Executed in 1994

PROVENANCE: Karsten Schubert Ltd., London

Narcissus
[p. 107]
Black and white photograph
7 × 12½in (17.8 × 31.8cm)

Executed in 1990, this work is an exhibition
copy, from an edition of 3 + 1

PROVENANCE: Karsten Schubert Ltd., London

LITERATURE: J. Thompson, 'Mat Collishaw',
Breda 1997 (another from the edition
illustrated in colour, p. 2).

Catching Fairies
[p. 108]
Hand tinted black and white photograph
7½ × 10¾in (9 × 7.3cm)

Executed in 1995

PROVENANCE: Karsten Schubert Ltd., London

Catching Fairies
[p. 109]
Hand tinted black and white photograph
7½ × 10¾in (19 × 27.3cm)

Executed in 1995

PROVENANCE: Karsten Schubert Ltd., London

Ultraviolet Angel
[p. 110]
Silkscreen with ultraviolet ink on paper,
ultraviolet light, galvanised steel box
14 × 9¾in (35.5 × 24.8cm)

Executed in 1993

PROVENANCE: Karsten Schubert Ltd., London

Ultraviolet Angel
[p. 111]
Silkscreen with ultraviolet ink on paper,
ultraviolet light, galvanised steel box
14 × 9¾in (35.5 × 24.8cm)

Executed in 1993

PROVENANCE: Karsten Schubert Ltd., London

Morning Toilet
[p. 112]
3 video stills
each: 10 × 3¾in (25.5 × 33.4cm)

Executed in 1996, this work is from an
edition of 3

PROVENANCE: Thomas Dane Ltd., London
Karsten Schubert Ltd., London

CARROLL DUNHAM (b. 1949)

Untitled
[p. 31]
Coloured pencils on paper
13¾ × 16¾in (35 × 42.5cm)

Executed in 1989

PROVENANCE: Jablonka Galerie, Köln

Floating Shape
[p. 32]
Vinyl, acrylic and pencil on canvas
77½ × 99¾in (196.8 × 252.3cm)

Painted in 1989–90

PROVENANCE: Sonnabend Gallery, New York

EXHIBITED: New York, Whitney Museum of
American Art, '1991 Biennal', April–June
1991 (illustrated in the catalogue in colour,
p. 57).

The Second Green Planet
[p. 33]
Vinyl, acrylic and pencil on canvas
84 × 54in (213.3 × 137.6cm)

Painted in 1996–97

PROVENANCE: Jablonka Galerie, Köln

Shape with Entrance
[pp. 34 and 35]
Vinyl, acrylic and pencil on canvas
91½ × 158in (232.5 × 401.4cm)

Painted in 1990

PROVENANCE: Sonnabend Gallery, New York

EXHIBITED: New York, Whitney Museum of
American Art, '1991 Biennal', April–June
1991 (illustrated in the catalogue in colour,
p. 57).

LITERATURE: 'American Art of the 80s', Milan
1991 (illustrated, p. 115).

R.M. FISHER (b. 1947)

Fountain
[p. 81]
Mixed media
88 × 23 × 29in (223.5 × 58.5 × 73.7cm)

Executed in 1987

PROVENANCE: Acquired directly from the artist

PETER HALLEY (b. 1953)

River's Edge
[pp. 18 and 19]
Day-Glo acrylic, acrylic and Roll-A-Tex on
two canvas
Overall: 90¼ × 195in (228 × 510cm)

Painted in 1990

PROVENANCE: Sonnabend Gallery, New York

EXHIBITED: Berlin, Martin-Gropius-Bau,
'Metropolis', April–July 1991, No. 60
(illustrated in the catalogue in colour, pp.
146–147).
Pully/Lausanne, FAE Musée d'Art
Contemporain, 'Peter Halley', April–May
1992, No. 26 (illustrated in the catalogue in
colour, p. 63). This exhibition travelled to
Madrid, Museo Reina Sofia.
Essen, Museum Folkwang, 'Peter Halley,
Bilder der 90er Jahre', November
1998–January 1999 (illustrated in the
catalogue in colour, p. 33).

Study for Double Elvis
[p. 21]
Acrylic on graph paper
17 × 22in (43.2 × 55.9cm)

Executed in 1990

PROVENANCE: Sonnabend Gallery, New York

The Place
[p. 23]
Day-Glo acrylic and Roll-A-Tex on canvas
95½ × 86in (242 × 218cm)

Painted in 1992

PROVENANCE: Galerie Thaddeus Ropac, Paris

EXHIBITED: Des Moines, Des Moines Art Center, 'Peter Halley, Paintings 1989–1992', October 1992–January 1993 (illustrated in the catalogue in colour, pl. 11).
Essen, Museum Folkwang, 'Peter Halley, Bilder der 90er Jahre', November 1998 – January 1999 (illustrated in the catalogue in colour, p. 37).

LITERATURE: R. Fleck, 'Peter Halley, Broad Conduit Boogie-Woogie', *Flash Art*, No. 165, Summer 1992 (illustrated in colour, p. 109).

Rob and Jack
[pp. 24 and 25]
Day-Glo acrylic, acrylic and Roll-A-Tex on two canvas
Overall: 90½ × 191in (229 × 495cm)

Painted in 1990

PROVENANCE: Jablonka Galerie, Köln

EXHIBITED: Bologna, Galeria Comunale d'Arte Moderna, 'Anni Novanta', May–September 1991 (illustrated in the catalogue in colour, p. 61). This exhibition travelled to Rimini, Musei Comunali and Catolica, ex colonia 'Le Navi'.
Trento, Palazzo delle Albere, 'American Art of the 80s', December 1991–March 1992, No. 16 (illustrated in the catalogue in colour, p. 54).

JENNY HOLZER (b. 1950)

Selection from the Survival Series (In a Dream I Saw ...)
[p. 86]
Cast aluminium plaque
5½ × 9½in (14 × 24cm)

Executed in 1983–85, this work is No. 2 from an edition of 10

PROVENANCE: Interim Art, London

Selection from the Survival Series (It's Easy to Get...)
[p. 87]
Cast aluminium plaque
8 × 10in (20.3 × 25.4cm)

Executed in 1983–84, this work is No. 2 from an edition of 10

PROVENANCE: Interim Art, London

GARY HUME (b. 1962)

Dolphin Painting No. IV
[pp. 100 and 101]
Gloss paint on four MDF boards
87½ × 253in (222 × 643cm)

Painted in 1991

Courtesy of the Saatchi Gallery, London

PROVENANCE: Karsten Schubert Ltd., London. Mohammad Mottahedan, The Saatchi Gallery, London (by 1996)

EXHIBITED: London, Karsten Schubert Ltd., 'Gary Hume: The Dolphin Paintings', 1991. The Saatchi Gallery, London, 'Fiona Rae/Gary Hume', January–April 1997. Royal Academy of Arts, London, 'Sensation: Young British Artists from the Saatchi Collection', September–December 1997.

LITERATURE: 'Young British Art, the Saatchi Decade', London 1999 (illustrated in colour, pp. 82–83).
'Gary Hume, XLVIII Venice Bienale', London 1999 (illustrated in colour, p. 77).

MICHAEL JENKINS (b. 1957)

Untitled
[p. 73]
Flashe and pencil on paper
36 × 24in (91.5 × 61cm)

Executed in 1991

PROVENANCE: Karsten Schubert Ltd., London

EXHIBITED: London, Karsten Schubert Ltd., 'We've lost ET but the boy's coming back: Peter Caine, Michael Jenkins, Michael Landy', November 1991.

Double Fence
[p. 79]
Wood with paint
60 × 26¾ × 8in (152.4 × 67.9 × 20.3cm)

Executed in 1990

PROVENANCE: Jay Gorney Modern Art Ltd., New York

DEBORAH KASS (b. 1952)

Hope and Glory
[p. 74]
Oil on canvas
45 × 90in (114.3 × 228.6cm)

Painted in 1987

JEFF KOONS (b. 1955)

Woman in Bath Tub
[p. 27]
Porcelain
24 × 36 × 27in (60.9 × 91.4 × 68.5cm)

Executed in 1988, this work is from an edition of 3

PROVENANCE: Sonnabend Gallery, New York

EXHIBITED: London, The Carnegie Museum of Art, '1988 Carnegie International' (illustrated in the supplement to the catalogue in colour, p. 179).
Los Angeles, The Museum of Contemporary Art, 'A Forest of Signs: Art in the Crisis of Representation', May–August 1989, No. 30.
Amsterdam, Stedelijk Museum, 'Jeff Koons', November 1992–January 1993 (illustrated

in the catalogue in colour, p. 77). This exhibition travelled to Aarhus, Kunstmuseum and Stuttgart, Staatsgalerie.

LITERATURE: S. Morgan, 'Big Fun', *ArtScribe International*, No. 74, March–April 1989 (illustrated in colour, p. 46).
R. Morgan, 'Jeff Koons', *New Art International*, June–July 1990 (illustrated in colour, p. 44).
A. Muthesius (Ed.), 'Jeff Koons', Köln 1992 (illustrated in colour, p. 122).

Winter Bears
[p. 28]
Painted wood
48 × 44 × 15½in (121.9 × 111.7 × 39.3cm)

Executed in 1988, this work is from an edition of 3

PROVENANCE: Max Hetzler Galerie, Köln

EXHIBITED: Basel, Kunsthalle, 'Mit dem Fernrohr durch die Kunstgeschichte, Von Galilei zu den Gebrüdern Montgolfier', August–October 1989, No. 50 (illustrated in the catalogue in colour).
Paris, Galerie Thaddeus Ropac, 'Vertigo', 1991 (illustrated in the catalogue in colour, pp. 65 and 75). This exhibition travelled to Salzburg, Galerie Thaddeus Ropac.
London, The Serpentine Gallery, 'Objects for the Ideal Home: The Legacy of Pop Art', September–October 1991 (illustrated in the catalogue in colour, p. 29, cover).
Amsterdam, Stedelijk Museum, 'Jeff Koons', November 1992–January 1993 (illustrated in Kunstmuseum and Stuttgart, Staatsgalerie).

LITERATURE: S. Morgan, 'Big Fun', *ArtScribe International*, No. 74, March–April 1989 (illustrated in colour, cover, frontispiece).
M. Sentis, 'The Importance of Being Banal', Lapiz, No. 61, October 1989 (illustrated in colour, p. 38).
Flash Art, No. 161, November–December 1991 (illustrated, p. 136).
'Pop Art', *Art & Design*, 1992 (illustrated in colour, p. 6 and back cover).
A. Muthesius (Ed.), 'Jeff Koons', Köln 1992 (illustrated in colour, p. 111).
K. Seward, 'Frankenstein in Paradise', *Parkett*, No. 50/51, 1997 (illustrated in colour, p. 80).

BARBARA KRUGER (b. 1945)

Untitled (I've Seen This Movie Before)
[pp. 88 and 89]
Lenticular photograph in artist's frame
each: 19 × 19in (48.2 × 48.2cm)

Executed in 1986

PROVENANCE: Mary Boone Gallery, New York

EXHIBITED: London, The Serpentine Gallery, 'Objects for the Ideal Home: The Legacy of Pop Art', September–October 1991 (illustrated in the catalogue in colour, pp. 40–41).

LITERATURE: *Flash Art*, No. 136, October 1987 (illustrated in colour, p. 59).

MICHAEL LANDY (b. 1963)

Appropriation 1
[p. 96]
9 cibachrome prints
each: 12 × 16in (30.4 × 40.6cm)

Executed in 1990, this work is from an edition of 6 + 3

PROVENANCE: Karsten Schubert Ltd., London

EXHIBITED: London, Karsten Schubert Ltd., 'Michael Landy: Appropriations', 1991 (illustrated in the catalogue in colour, p. 5).

Appropriation 2
[p. 97]
9 cibachrome prints
each: 12 × 16in (30.4 × 40.6cm)

Executed in 1990, this work is from an edition of 6 + 3

PROVENANCE: Karsten Schubert Ltd., London

EXHIBITED: London, Karsten Schubert Ltd., 'Michael Landy: Appropriations', 1991 (illustrated in the catalogue in colour, p. 7).

Appropriation 3
[p. 98]
9 cibachrome prints
each: 12 × 16in (30.4 × 40.6cm)

Executed in 1990, this work is from an edition of 6 + 3

PROVENANCE: Karsten Schubert Ltd., London

EXHIBITED: London, Karsten Schubert Ltd., 'Michael Landy: Appropriations', 1991 (illustrated in the catalogue in colour, p. 9).

Appropriation 4
[p. 99]
9 cibachrome prints
each: 12 × 16in (30.4 × 40.6cm)

Executed in 1990, this work is from an edition of 6 + 3

PROVENANCE: Karsten Schubert Ltd., London

EXHIBITED: London, Karsten Schubert Ltd., 'Michael Landy: Appropriations', 1991 (illustrated in the catalogue in colour, p. 11).

PETER NAGY (b. 1959)

Excelsior
[p. 68]
Acrylic on canvas
72 × 72in (182.8 × 182.8cm)

Painted in 1988

PROVENANCE: Jay Gorney Modern Art Ltd., New York

Circus Mort
[p. 69]
Acrylic on canvas
72 × 72in (182.8 × 182.8cm)

Painted in 1989

PROVENANCE: Jablonka Galerie, Köln

Microbe
[p. 70]
Acrylic on canvas
48 × 48in (121.9 × 121.9cm)

Painted in 1987

PROVENANCE: Jay Gorney Modern Art Ltd., New York

TOM RADLOFF (b. 1958)

Green Lexicon # 64
[p. 75]
Acrylic on paper on plaster on wood
48 × 52in (121.9 × 132cm)

Executed in 1988

Light Green Stump # 44
[p. 76]
Acrylic on paper on plaster on wood
26 × 22in (66 × 55.8cm)

Executed in 1987

Light Green Screw # 343
[p. 77]
Acrylic on paper on plaster on wood
26 × 22in (66 × 55.8cm)

Executed in 1987

ALEXIS ROCKMAN (b. 1962)

Phylum
[p. 37]
Oil on canvas
112 × 66in (284.4 × 167.6cm)

Painted in 1989

PROVENANCE: Jay Gorney Modern Art Ltd.,
New York

LITERATURE: J. Saltz, 'A Thorn Tree in the
Garden', *Arts Magazine*, September 1989
(illustrated in colour, p. 13).
O. Zaya, 'Mientras el Gusano se Transforma:
la Pintura de Alexis Rockman', Balcon, 1991
(illustrated in colour, p. 49).

Untitled
[p. 38]
Oil on canvas
32 × 48in (81.2 × 121.9cm)

Painted in 1988

PROVENANCE: Jay Gorney Modern Art Ltd.,
New York

LITERATURE: *Art In America*, June 1989
(illustrated in colour, p. 168).

Parade
[p. 39]
Oil on canvas
60 × 112in (152.4 × 284.4cm)

Painted in 1987

PROVENANCE: Jay Gorney Modern Art Ltd.,
New York

EXHIBITED: London, Institute of Contemporary
Art, 'The Institute of Cultural Anxiety, Works
from the Collection', December
1994–February 1995 (illustrated in the
catalogue in colour).

LITERATURE: R. Martin, 'Alexis Rockman: An Art
Between Taxonomy and Taxidermy', Arts
Magazine, October 1987 (illustrated in
colour, p. 22).

TIM ROLLINS (b. 1955) **+ K.O.S.**

Amerika – For Karl
[p. 41]
Watercolour on book pages on linen
92 × 132in (233.6 × 335.2cm)

Painted in 1989

PROVENANCE: Jay Gorney Modern Art Ltd.,
New York

EXHIBITED: Trento, Palazzo delle Albere,
'American Art of the 80s', December
1991–March 1992, No. 35 (illustrated in
the catalogue in colour, p. 74).

Oklahoma
[pp. 42 and 43]
Bronze sculpture on wooden base
82.3 × 31.4 × 31.4in (210 × 80 × 80cm)

Executed in 1993, this work is unique

PROVENANCE: Acquired directly from the artist

Amerika Gold
[p. 45]
Acrylic on book pages on linen
48 × 72in (121.9 × 182.8cm)

Painted in 1990

PROVENANCE: Acquired directly from the artist

The Scarlet Letter
[p. 46]
Acrylic on book pages
36 × 42in (91.4 × 106.6cm)

Painted in 1987–89

PROVENANCE: Jay Gorney Modern Art Ltd.,
New York

The Red Badge of Courage
[p. 47]
Acrylic on book pages on linen
48 × 72in (121.9 × 182.8cm)

Painted in 1990

PROVENANCE: Interim Art, London

Untitled
[p. 48]
Acrylic on 6 book pages
Each: 8 × 5in (20.3 × 12.7cm)

Painted in 1989

PROVENANCE: Johnen & Schottle Galerie, Köln

Animal Farm – G7
[p. 51]
Acrylic on book pages on linen
48 × 72in (121.9 × 182.8cm)

Painted in 1989–92

PROVENANCE: Mary Boone Gallery, New York,
commissioned directly from the artist

EXHIBITED: New York, Metropolitan
Transportation Authority, Grand Central
Terminal, Main Waiting Room, 'Animal Farm',
October 1994.
London, Oldham Art Gallery, 'Imagined
Communities', January–March 1996
(illustrated in the catalogue in colour, pp.
46–47). This exhibition travelled to the
University of Southampton, John Hansard
Gallery, Colchester, Firstsite at the Minories,
Walsall, Walsall Museum and Art Gallery,
London, Royal Festival Hall and Glasgow,
Gallery of Modern Art.

Animal Farm – New World Order
[p. 52]
Acrylic on book pages on linen
48 × 72in (121.9 × 182.8cm)

Painted in 1989–92

PROVENANCE: Mary Boone Gallery, New York, commissioned directly from the artist

EXHIBITED: New York, Metropolitan Transportation Authority, Grand Central Terminal, Main Waiting Room, 'Animal Farm', October 1994.
London, Oldham Art Gallery, 'Imagined Communities', January–March 1996 (illustrated in the catalogue in colour, pp. 46–47). This exhibition travelled to the University of Southampton, John Hansard Gallery, Colchester, Firstsite at the Minories, Walsall, Walsall Museum and Art Gallery, London, Royal Festival Hall and Glasgow, Gallery of Modern Art.

Animal Farm – Big Three
[p. 55]
Acrylic on book pages on linen
48 × 72in (121.9 × 182.8cm)

Painted in 1989–92

PROVENANCE: Mary Boone Gallery, New York, commissioned directly from the artist

EXHIBITED: New York, Metropolitan Transportation Authority, Grand Central Terminal, Main Waiting Room, 'Animal Farm', October 1994.
London, Oldham Art Gallery, 'Imagined Communities', January–March 1996 (illustrated in the catalogue in colour, pp. 46–47). This exhibition travelled to the University of Southampton, John Hansard Gallery, Colchester, Firstsite at the Minories, Walsall, Walsall Museum and Art Gallery, London, Royal Festival Hall and Glasgow, Gallery of Modern Art.

MICHAEL SCOTT (b. 1958)

Untitled
[p. 71]
Enamel on aluminium
96 × 48in (243.8 × 121.9cm)

Painted in 1989

PROVENANCE: Tony Shafrazi Gallery, New York

CINDY SHERMAN (b. 1954)

Untitled # 152
[p. 82]
c-print
72½ × 49½in (184.1 × 125.4cm)

Executed in 1985, this work is No. 4 from an edition of 6

PROVENANCE: Metro Pictures, New York

EXHIBITED: New York, Whitney Museum of American Art, 'Cindy Sherman', July–October 1987 (illustrated in colour, pl. 99)

LITERATURE: 'Cindy Sherman, 1975–1993', New York 1993 (another from the edition illustrated in colour, p. 128).

LAURIE SIMMONS (b. 1949)

Talking Handkerchief
[p. 83]
c-print
63½ × 48in (161.2 × 121.9cm)

Executed in 1987, this work is No. 2 from an edition of 5

PROVENANCE: Metro Pictures, New York

English Lady
[p. 84]
c-print
36 × 26in (91.4 × 66cm)

Executed in 1987, this work is No. 2 from an edition of 5

PROVENANCE: Metro Pictures, New York

Two Faced Figure
[p. 85]
c-print
32 × 26in (91.4 × 66cm)

Executed in 1987, this work is No. 2 from an edition of 5

PROVENANCE: Metro Pictures, New York

HAIM STEINBACH (b. 1944)

Untitled (Cabbage, Pumpkin, Pitchers)
[p. 56]
Mixed media construction
54 × 89 × 28in (137.1 × 226 × 71.1cm)

Executed in 1986

PROVENANCE: Jay Gorney Modern Art Ltd., New York

EXHIBITED: Trento, Palazzo delle Albere, 'American Art of the 80s', December 1991–March 1992, No. 46 (illustrated in the catalogue in colour, p. 86).

Untitled (Cabbage, Pumpkin, Cabbage No. 1)
[p. 57]
Mixed media construction
52½ × 47 × 27½in
(133.3 × 119.3 × 69.8cm)

Executed in 1987

PROVENANCE: Jay Gorney Modern Art Ltd., New York

EXHIBITED: London, The Serpentine Gallery, 'Objects for the Ideal Home: The Legacy of Pop Art', September–October 1991 (illustrated in the catalogue in colour, p. 31).

LITERATURE: 'Pop Art', *Art & Design*, 1992 (illustrated in colour, p. 96).

GARY STEPHAN (b. 1952)

They Are and We Can ©
[p. 64]
Acrylic on linen
36 × 24in (91.4 × 60.9cm)

Painted in 1987

PROVENANCE: Mary Boone Gallery, New York

LITERATURE: R. Pincus-Witten, 'Gary Stephan, Spectacles and Con-Template-Ion', *Flash Art*, No. 140, May–June 1988 (illustrated, p. 77).

Moom
[p. 65]
Acrylic on linen
16 × 12¾in (40.6 × 32.3cm)

Painted in 1987

PROVENANCE: Mary Boone Gallery, New York

MEYER VAISMAN (b. 1960)

Untitled
[p. 58]
Cotton, silk, wool, two stuffed turkeys on two wooden bases
Overall: 64 × 32 × 21in
(162.5 × 81.3 × 53.3cm)

Executed in 1994

PROVENANCE: Jablonka Galerie, Köln, commissioned directly from the artist

EXHIBITED: Helsinki, Museum of Contemporary Art, 'Ars 95', February–May 1995, No. 149 (illustrated in the catalogue, p. 237).

Still Life with Portrait
[p. 59]
Printing inks on canvas
96 × 96 × 8½in (244 × 244 × 22cm)

Executed in 1988

PROVENANCE: Jablonka Galerie, Köln

EXHIBITED: Köln, Jablonka Galerie, 'Meyer Vaisman', 1989 (illustrated in the catalogue in colour).
London, The Serpentine Gallery, 'Objects for the Ideal Home: The Legacy of Pop Art', September–October 1991 (illustrated in the catalogue in colour, p. 30).

Untitled
[p. 72]
Acrylic on canvas
36 × 24in (91.4 × 60.9cm)

Executed in 1988

PROVENANCE: Jay Gorney Modern Art Ltd., New York

ANDY WARHOL (1928–87)

Untitled
[p. 94]
Graphite on HMP paper
40 × 30in (102.5 × 78.2cm)

Executed in 1981

PROVENANCE: The Andy Warhol Foundation, New York
Jablonka Galerie, Köln

EXHIBITED: Köln, Jablonka Galerie, 'Andy Warhol, Modern Madonna', June–July 1999 (illustrated in the catalogue, p. 15).

Untitled
[p. 95]
Graphite on HMP paper
31 × 24in (78.7 × 61cm)

Executed in 1981

PROVENANCE: The Andy Warhol Foundation, New York
Jablonka Galerie, Köln

EXHIBITED: Köln, Jablonka Galerie, 'Andy Warhol, Modern Madonna', June–July 1999 (illustrated in the catalogue, p. 11).

OLIVER WASOW (b. 1960)

Untitled # 148C
[p. 93]
c-print
24 × 12in (61 × 30.5cm)

Executed in 1986

PROVENANCE: Josh Baer, New York

EXHIBITED: Boston, The Institute of Contemporary Art, 'Utopia Post Utopia: Configurations of Nature and Culture in Recent Sculpture and Photography', January–March 1988 (illustrated in the catalogue in colour, p. 74).

JAMES WELLING (b. 1951)

Untitled (100A)
[p. 66]
Oil on canvas
24 × 24in (60.9 × 60.9cm)

Painted in 1987

PROVENANCE: Jay Gorney Modern Art Ltd., New York

Untitled (100B)
[p. 67]
Oil on canvas
24 × 24in (60.9 × 60.9cm)

Painted in 1987

PROVENANCE: Jay Gorney Modern Art Ltd., New York

CHRISTOPHER WOOL (b. 1955)

Untitled
[p. 29]
Alkyd and acrylic on aluminium
96 × 64½in (244 × 163cm)

Painted in 1989

PROVENANCE: Max Hetzler Galerie, Köln

EXHIBITED: London, Karsten Schubert Ltd., 'Michael Craig-Martin, Gary Hume, Christopher Wool; A Paintings Show', 1990 (illustrated in the catalogue, p. 16).
Rotterdam, Museum Boymans-van Beuningen, 'Christopher Wool, Cats in Bag, Bags in River', February–April 1991 (illustrated in the catalogue). This exhibition travelled to Köln, Kunstverein.
Los Angeles, The Museum of Contemporary Art, 'Christopher Wool', July–October 1998 (illustrated in the catalogue, p. 160). This exhibition travelled to Pittsburgh, Carnegie Museum of Art.

Once upon a time in America
: The Mottahedan Collection

DEC v 2002